10 STEP DRAWING

Cute Animals

Published in 2024 by Search Press Ltd.
Wellwood, North Farm Road
Tunbridge Wells
Kent TN2 3DR

This book is produced by
The Bright Press, an imprint of the Quarto Group,
1 Triptych Place, London SE1 9SH,
United Kingdom.
T (0)20 7700 6700
www.Quarto.com

ISBN: 978-1-80092-236-5
ebook ISBN: 978-1-80093-216-6

Publisher: James Evans
Editorial Director: Isheeta Mustafi
Art Director: James Lawrence
Managing Editor: Jacqui Sayers
Senior Editor: Dee Costello
Project Editor: Polly Goodman
Design: JC Lanaway

Printed and bound in China

Bookmarked Hub
For further ideas and inspiration, and to join our free
online community, visit www.bookmarkedhub.com

Cute Animals

10 STEP DRAWING

DRAW OVER ⑤⓪ ADORABLE ANIMALS IN 10 EASY STEPS

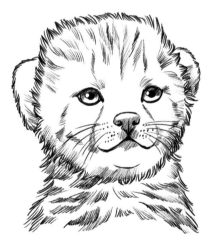

JUSTINE LECOUFFE

Search Press

Contents

⫸ Deserts & Savanna

⫸ Forests & Mountains

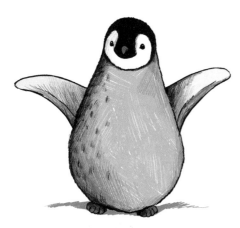

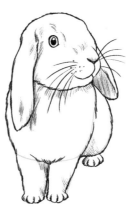

>>> Arctic & Oceans

>>> Woodlands & Wetlands

>>> Domestic Animals

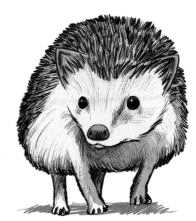

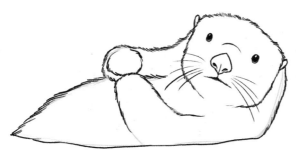

Introduction

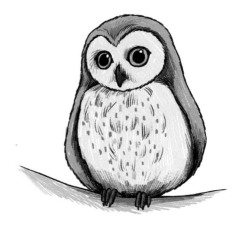

In this book, you will find more than 50 illustrations of adorably cute creatures in a variety of profiles and poses, and over a range of habitats, all created in just 10 simple steps. So, whether it's a sleeping sloth, a fluffy owl, or a tree-hugging panda, it's time to choose your favourite cute animal and get drawing!

TACKLING DIFFERENT SHAPES

There are millions of species of animals across every continent, and they come in different shapes and sizes. The step-by-step instructions in this book show you how to use simple shapes or outlines as guides for placing heads, limbs, wings, fins and tails. This will enable you to get the proportions right. Follow the instructions and guides for the shapes to help you achieve a realistic appearance for each animal, as well as a variety of natural poses, from lounging on a tree branch to munching on food.

COLOURS

At the end of each finished drawing you'll find a colour palette. Use this as a guide, but feel free to use your favourite fur or feather colours instead.

I hope you will enjoy creating the images in this book as much as I did. Drawing cute animals has never been easier!

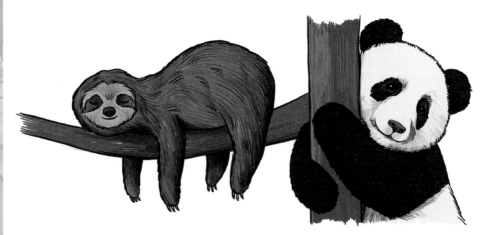

How to use this book

BASIC EQUIPMENT

Paper: Any paper will do, but sketch paper will give you the best results.

Pencil, rubber and pencil sharpener: Try different pencil grades and invest in a good-quality rubber and sharpener.

Coloured pencils: A good set of coloured pencils, with about 24 shades, is really all you need.

Small ruler: This is optional, but you may find it useful for drawing guidelines.

FOLLOWING THE STEPS

Use a pencil to draw the shape guidelines in each step. Use a dark-coloured pencil to add the outlines and details. Then erase the underlying pencil. Finally, apply colour as you like.

> **Top Tip:**
> The guidelines in each step are shown in blue and purple. These should be erased once the dark outlines are completed and before colour is applied.

COLOURING

You have several options when it comes to colouring your drawings – why not explore them all?

Pencils: This is the simplest option, and the one used for the drawings in this book.

Stay inside the lines and keep your pencils sharp so you have control in the smaller areas.

To achieve a lighter or darker shade, try layering the colour, or pressing harder with your pencil.

Animal coats, feathers and scales come in different patterns, colours and textures, so once you're confident with where the shading should be on each one, try varying the tones you use.

Paint and brush: Watercolour is probably easiest to work with for beginners, although using acrylic or oil means that you can paint over any mistakes. You'll need two or three brushes of different sizes, with at least one very fine brush.

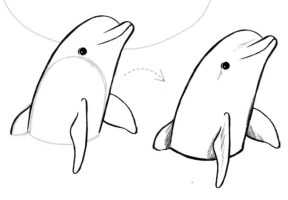

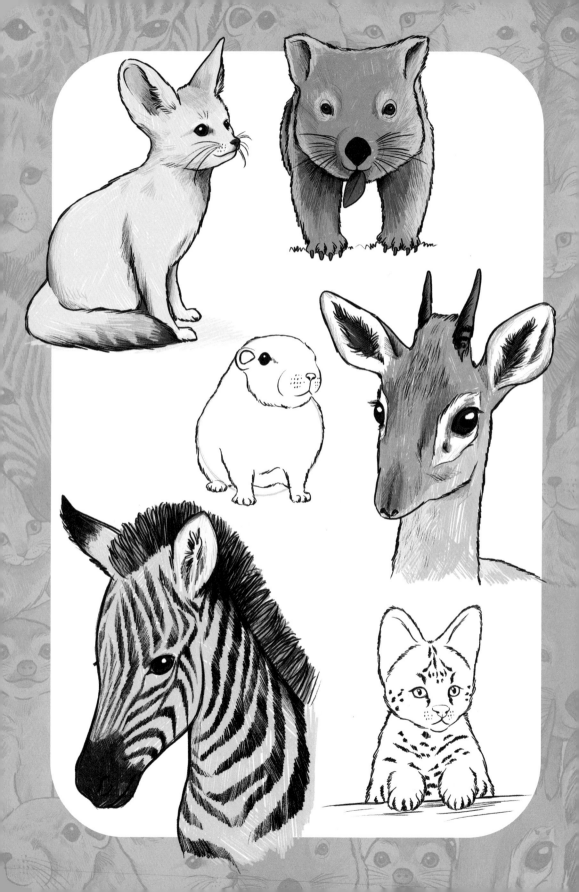

Deserts & Savanna

Sand cat

With its large ears, furry paws and big, green eyes, the sand cat
has all the cute features you need to get started.

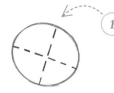

1) Draw an oval as a guide for
the head. Add a cross of
two dashed lines, as shown.
These will help position the
eyes, nose and mouth.

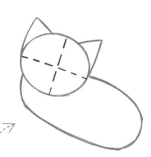

2) Add two triangles for the
ears, and a long, oval shape
for the body.

3) Trace the front legs,
adding ovals for the feet.
Notice the different angles
of each leg and how one
overlaps the body.

4) Sketch the curvy hind leg.
Add a line for the branch
the cat is on.

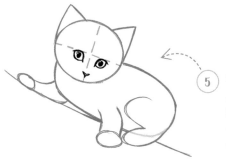

5) With a dark pencil, draw big, round
eyes under the horizontal guide. Add
black pupils, with tiny reflection circles
to the top left. Add a delicate,
triangular nose on the vertical guide.

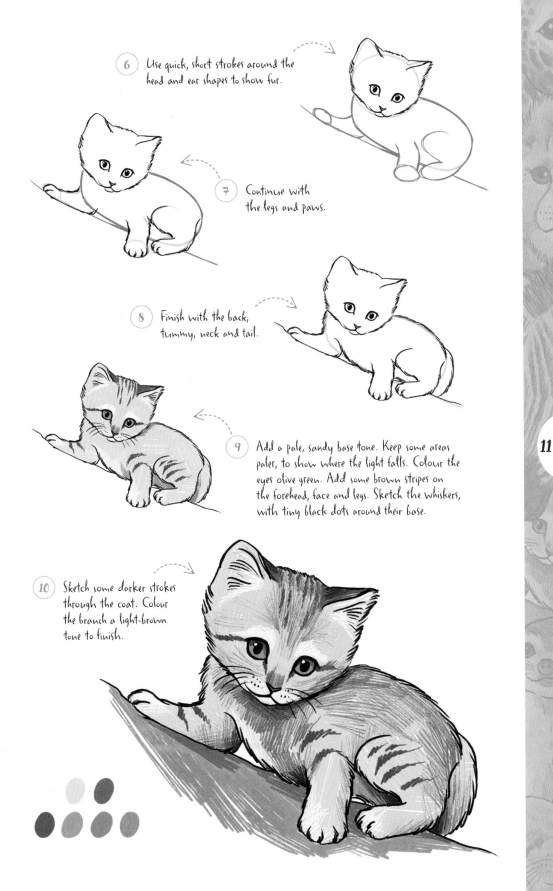

6 Use quick, short strokes around the head and ear shapes to show fur.

7 Continue with the legs and paws.

8 Finish with the back, tummy, neck and tail.

9 Add a pale, sandy base tone. Keep some areas paler, to show where the light falls. Colour the eyes olive green. Add some brown stripes on the forehead, face and legs. Sketch the whiskers, with tiny black dots around their base.

10 Sketch some darker strokes through the coat. Colour the branch a light-brown tone to finish.

Gundi

Who would believe you could get so much cute factor in
a rodent measuring not much bigger than a hand?

1 Draw a circle guide for
the head, with a dashed
line across the centre.
Add a small oval to
the top left for the ear.

2 Add a larger, overlapping
circle below the head. It
should be around twice
the size of the head.

3 Connect the head to the
body with a curve to form
the neck. Add the front
legs, with two circles for
the feet. Add a circle to
the left for the hind foot.

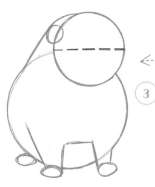

4 Draw the large, round
eye with pointed edges.
Add a dark pupil, with
a tiny reflection circle
inside. Sketch the nose
and mouth.

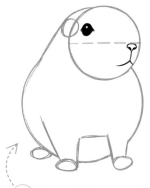

5 Add the outlines of the
ear. Sketch two curves
for the muzzle. Add
some dots to show the
base of the whiskers.

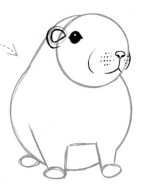

6 Sketch fur around the head with a series of short strokes.

7 Continue with the legs and feet.

8 Finish the outline of the body. Notice the shape of the belly and the extra fold of fur between the front legs.

9 Add an orange-brown base tone, keeping the outer edges of the ear, eye and feet lighter to show where the light falls.

10 Add some darker tones to the areas in shade, and some green strokes below for grass. Finish with some darker strokes around the coat to make it more furry.

Serval

The large, furry ears of this African wild cat help it when hunting prey.
They also place it high in the cute stakes!

1 Draw a circle guide for the head. Add a slightly angled, dashed line across the centre.

2 Trace two arcs above the head for the ears. Add a curved, vertical line through the centre, and a smaller circle guide below for the muzzle.

3 Sketch the upper body and legs, with circles for the feet and a horizontal line for the branch.

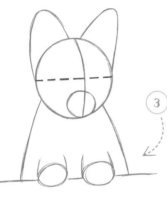

14

4 Draw the eyes below the horizontal guide. Add black pupils, with tiny reflection circles to the top left. Draw the nose and mouth within the smaller circle guide.

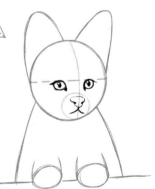

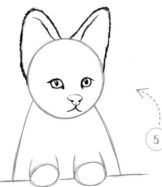

5 Trace the furry ears with a series of short strokes.

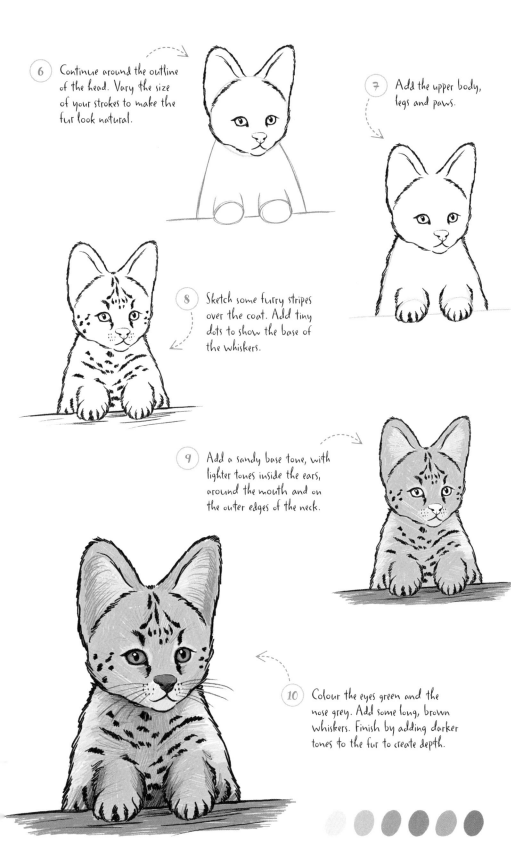

6 Continue around the outline of the head. Vary the size of your strokes to make the fur look natural.

7 Add the upper body, legs and paws.

8 Sketch some furry stripes over the coat. Add tiny dots to show the base of the whiskers.

9 Add a sandy base tone, with lighter tones inside the ears, around the mouth and on the outer edges of the neck.

10 Colour the eyes green and the nose grey. Add some long, brown whiskers. Finish by adding darker tones to the fur to create depth.

Giraffe

Drawing the delicate outline of the giraffe's head is easy when using these simple shape guides.

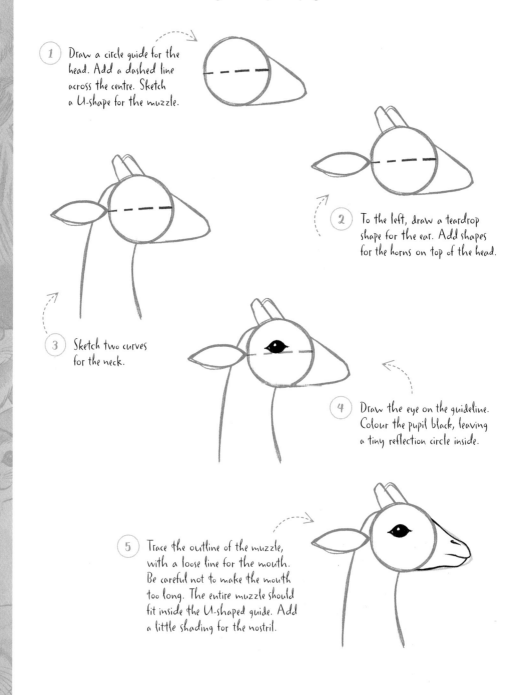

1. Draw a circle guide for the head. Add a dashed line across the centre. Sketch a U-shape for the muzzle.

2. To the left, draw a teardrop shape for the ear. Add shapes for the horns on top of the head.

3. Sketch two curves for the neck.

4. Draw the eye on the guideline. Colour the pupil black, leaving a tiny reflection circle inside.

5. Trace the outline of the muzzle, with a loose line for the mouth. Be careful not to make the mouth too long. The entire muzzle should fit inside the U-shaped guide. Add a little shading for the nostril.

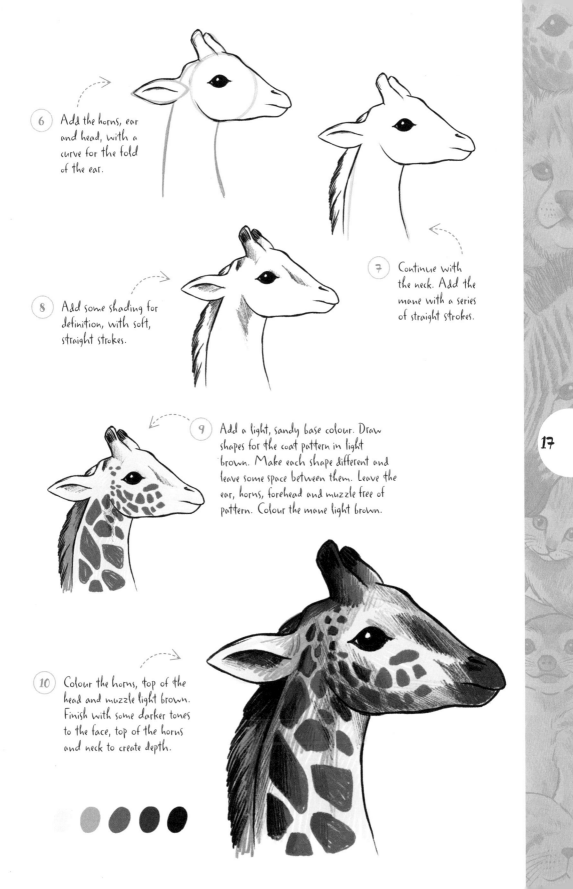

6 Add the horns, ear and head, with a curve for the fold of the ear.

7 Continue with the neck. Add the mane with a series of straight strokes.

8 Add some shading for definition, with soft, straight strokes.

9 Add a light, sandy base colour. Draw shapes for the coat pattern in light brown. Make each shape different and leave some space between them. Leave the ear, horns, forehead and muzzle free of pattern. Colour the mane light brown.

10 Colour the horns, top of the head and muzzle light brown. Finish with some darker tones to the face, top of the horns and neck to create depth.

Dik-dik

The world's smallest antelope, the dik-dik has big, brown eyes
and enormous, furry ears, making it a joy to draw.

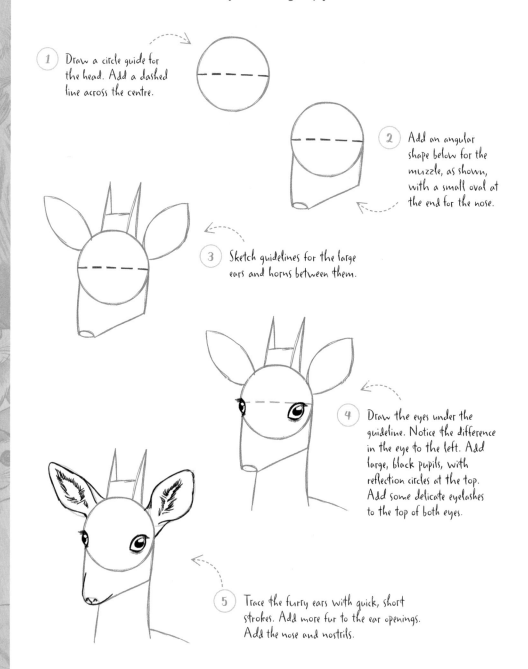

1 Draw a circle guide for
 the head. Add a dashed
 line across the centre.

2 Add an angular
 shape below for the
 muzzle, as shown,
 with a small oval at
 the end for the nose.

3 Sketch guidelines for the large
 ears and horns between them.

4 Draw the eyes under the
 guideline. Notice the difference
 in the eye to the left. Add
 large, black pupils, with
 reflection circles at the top.
 Add some delicate eyelashes
 to the top of both eyes.

5 Trace the furry ears with quick, short
 strokes. Add more fur to the ear openings.
 Add the nose and nostrils.

18

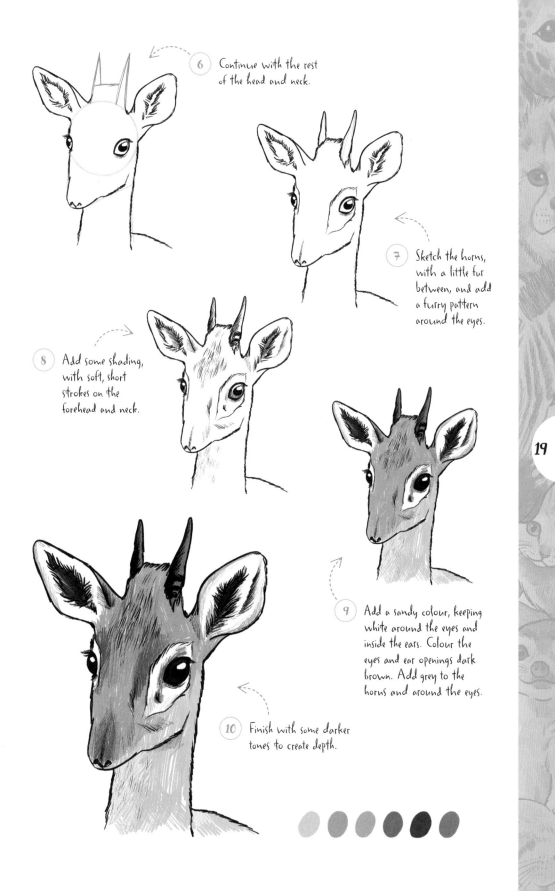

6 Continue with the rest of the head and neck.

7 Sketch the horns, with a little fur between, and add a furry pattern around the eyes.

8 Add some shading, with soft, short strokes on the forehead and neck.

9 Add a sandy colour, keeping white around the eyes and inside the ears. Colour the eyes and ear openings dark brown. Add grey to the horns and around the eyes.

10 Finish with some darker tones to create depth.

19

Meerkat

Meerkats are constantly alert, often standing sentry and turning their heads around to catch the sound of danger.

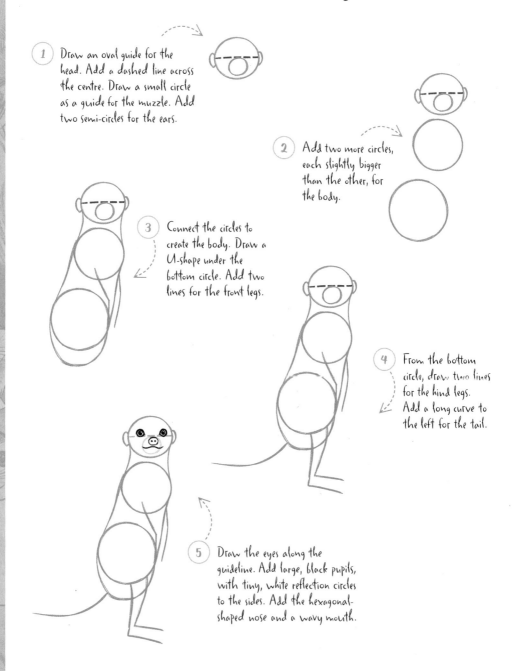

1. Draw an oval guide for the head. Add a dashed line across the centre. Draw a small circle as a guide for the muzzle. Add two semi-circles for the ears.

2. Add two more circles, each slightly bigger than the other, for the body.

3. Connect the circles to create the body. Draw a U-shape under the bottom circle. Add two lines for the front legs.

4. From the bottom circle, draw two lines for the hind legs. Add a long curve to the left for the tail.

5. Draw the eyes along the guideline. Add large, black pupils, with tiny, white reflection circles to the sides. Add the hexagonal-shaped nose and a wavy mouth.

20

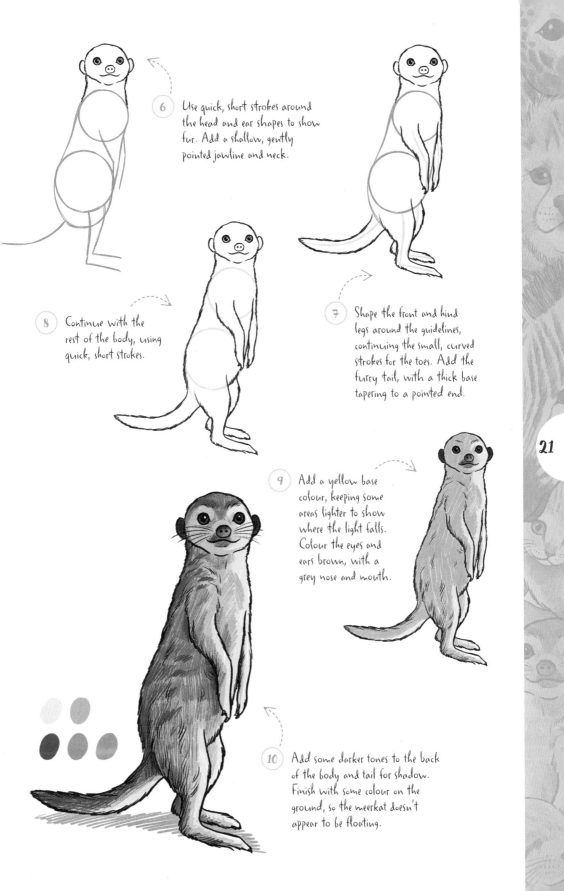

6 Use quick, short strokes around the head and ear shapes to show fur. Add a shallow, gently pointed jawline and neck.

8 Continue with the rest of the body, using quick, short strokes.

7 Shape the front and hind legs around the guidelines, continuing the small, curved strokes for the toes. Add the furry tail, with a thick base tapering to a pointed end.

9 Add a yellow base colour, keeping some areas lighter to show where the light falls. Colour the eyes and ears brown, with a grey nose and mouth.

10 Add some darker tones to the back of the body and tail for shadow. Finish with some colour on the ground, so the meerkat doesn't appear to be floating.

21

Fennec fox

It might be the smallest fox species, but the fennec fox makes up for it with its enormous ears.

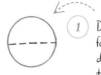

1. Draw a circle guide for the head. Add a dashed line across the centre.

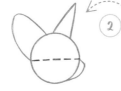

2. Add a U-shape and a triangle for the big ears. Add a shallow U-shape to the bottom right for the muzzle.

3. Draw another circle for the body, as shown. This circle should be twice the size of the head circle.

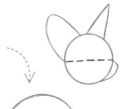

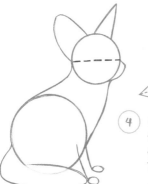

4. Connect the two circles to create the neck and chest. Add a loose tube shape below for the tail. Then add lines for the legs, with circles on the end for the feet.

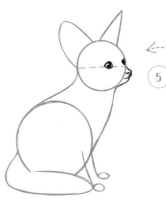

5. Draw one eye across the guideline, and the other, smaller eye slightly above it. Notice the effect of perspective on the size and shapes of the eyes. Add black pupils, including tiny reflection circles. Draw the outline of the nose, mouth and chin using the muzzle guideline.

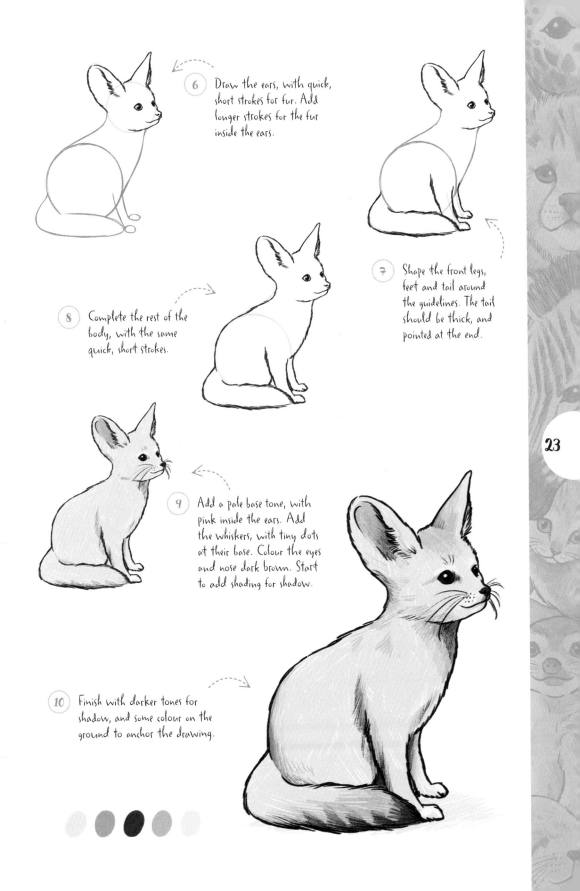

6 Draw the ears, with quick, short strokes for fur. Add longer strokes for the fur inside the ears.

7 Shape the front legs, feet and tail around the guidelines. The tail should be thick, and pointed at the end.

8 Complete the rest of the body, with the same quick, short strokes.

9 Add a pale base tone, with pink inside the ears. Add the whiskers, with tiny dots at their base. Colour the eyes and nose dark brown. Start to add shading for shadow.

10 Finish with darker tones for shadow, and some colour on the ground to anchor the drawing.

Wombat

This Australian relative of the kangaroo has powerful claws,
which it uses to dig extensive burrows.

(1) Draw a circle guide for the head. Add a smaller circle within it for the nose.

(2) Add two triangles for the ears. Draw a dashed line across the centre.

(3) Sketch guides for the front legs, with ovals for the feet. Add a small curve to the left for the side of the body.

24

(4) Add a leaf shape under the nose. Draw the eyes above the guideline. Add black pupils, with tiny reflection circles inside. Add the nose below.

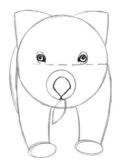

(5) Sketch the whiskers and the leaf coming out of the mouth.

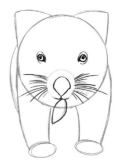

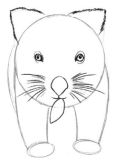

6 Trace the furry ears, using quick, short strokes.

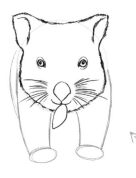

7 Continue around the rest of the face, adding furry curves for the ear openings.

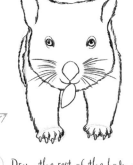

8 Draw the rest of the body and legs, adding furry toes and claws.

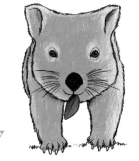

9 Add a grey base colour. Use brown for the eyes, darker brown for the nose and green for the leaf.

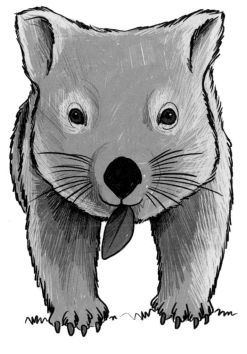

10 Finish your drawing with some darker tones to the areas in shade.

Zebra

Building from a simple circle, to a cone and a curve will help you
get the proportions of this zebra foal's head just right.

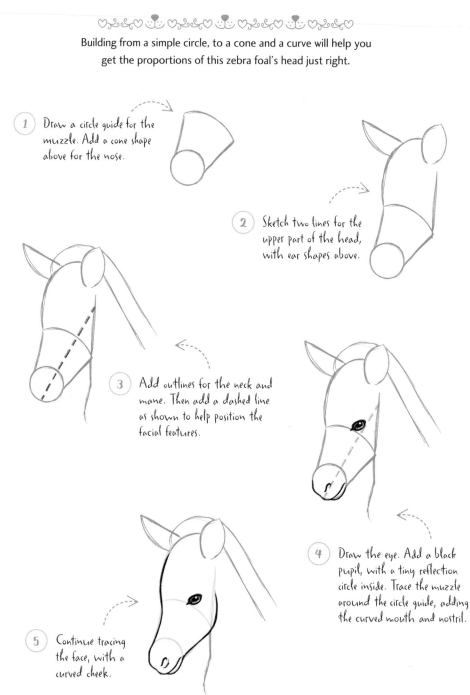

1. Draw a circle guide for the muzzle. Add a cone shape above for the nose.

2. Sketch two lines for the upper part of the head, with ear shapes above.

3. Add outlines for the neck and mane. Then add a dashed line as shown to help position the facial features.

4. Draw the eye. Add a black pupil, with a tiny reflection circle inside. Trace the muzzle around the circle guide, adding the curved mouth and nostril.

5. Continue tracing the face, with a curved cheek.

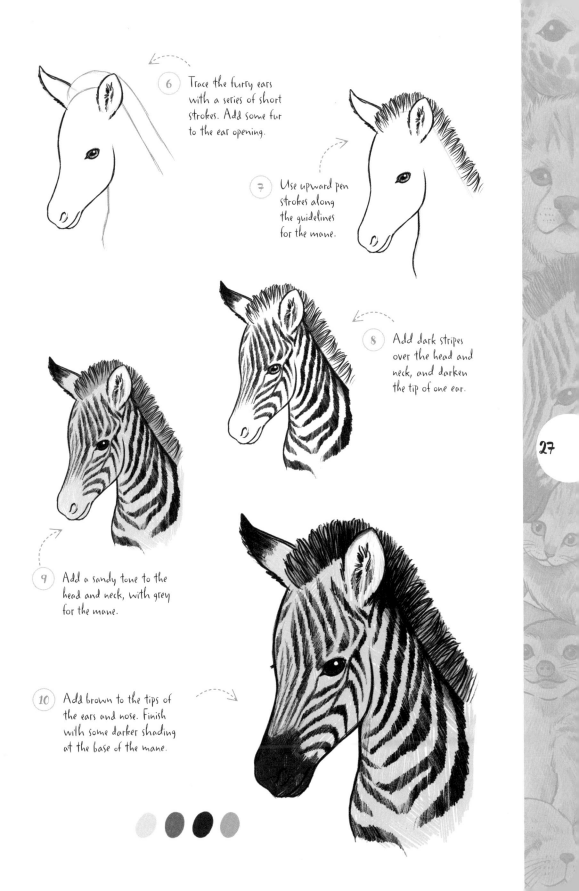

6 Trace the furry ears with a series of short strokes. Add some fur to the ear opening.

7 Use upward pen strokes along the guidelines for the mane.

8 Add dark stripes over the head and neck, and darken the tip of one ear.

9 Add a sandy tone to the head and neck, with grey for the mane.

10 Add brown to the tips of the ears and nose. Finish with some darker shading at the base of the mane.

Cheetah

This cuter-than-cute cheetah cub gives a chance
to practise your softest, fluffiest strokes.

1 Draw a circle guide for the
head. Add a dashed line
across the centre.

2 Add a curved, vertical line
through the centre, and two
small semi-circles for the ears.

3 Sketch two circles for the eyes
above the horizontal guideline
and an oval for the muzzle
below. Add two lines for
the neck.

4 Draw the eyes along the
horizontal guide. Add black
pupils, with tiny reflection
circles inside.

5 Position the nose and
mouth inside the oval guide.

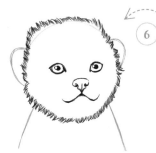

6 Trace the cheetah's fur around the circle guide with lots of short strokes. Vary the shape and size of the strokes for a natural look.

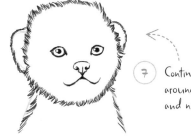

7 Continue the fur around the ears and neck.

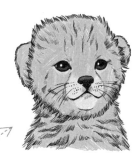

8 Add more fur strokes. Always make the strokes in the general direction of the fur. The more strokes you add, the more detailed the fur will appear. Add black whiskers, with tiny dots at their base.

9 Start to add colour with a sandy tone. Use a paler colour for the muzzle and under the eyes. Colour the eyes brown and the nose a dark grey.

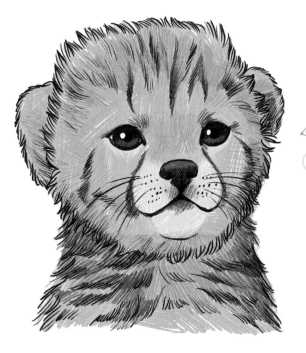

10 Finish with some darker tones around the nose, head and neck.

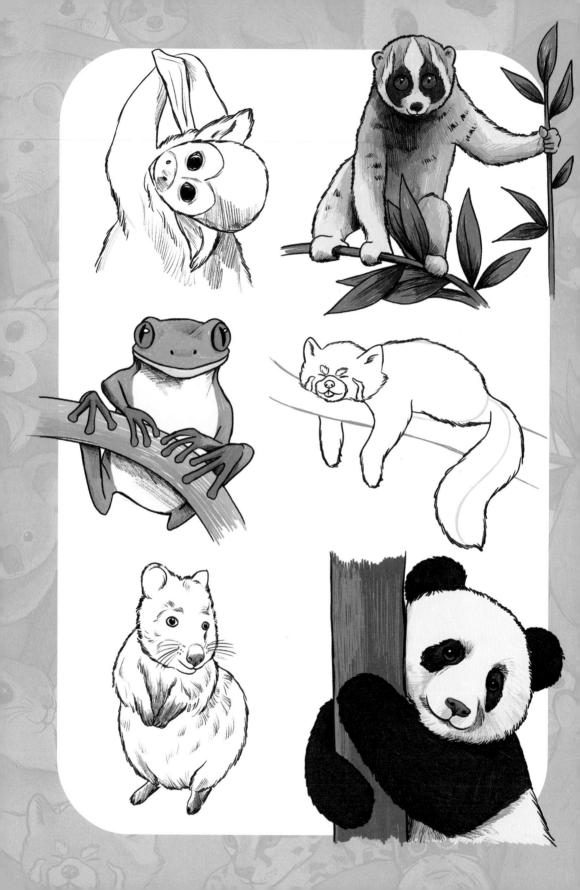

Forests & Mountains

Siberian flying squirrel

The large, strikingly black eyes and delicate, pink nose of the Siberian
flying squirrel earn it a place amongst the top cutest creatures.

1 Draw a circle guide for the
head. Add a dashed line across
the centre. Now add a small
oval to the top left for the ear.

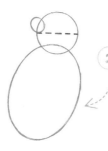

2 Add a long oval shape
overlapping the head circle
as a guide for the body.

3 Draw a line for the arm, with a circle
at the end for the front paw. Under
the oval guide, sketch an arc for
the tail. Add a narrow rectangle
to the right for the foot.

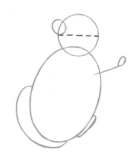

4 Connect the oval and circle guides
to create the neck. Add a long
line for the branch on the right.

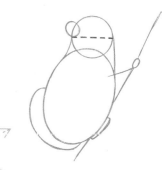

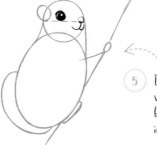

5 Draw the round eye on the horizontal guide,
with thick eyelashes above. Add the large,
black pupil, keeping a white reflection circle
inside. Draw the nose and mouth.

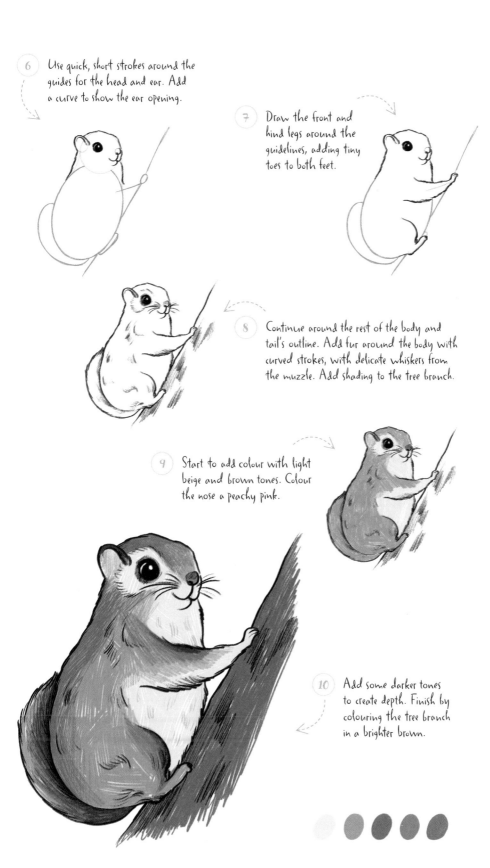

6 Use quick, short strokes around the guides for the head and ear. Add a curve to show the ear opening.

7 Draw the front and hind legs around the guidelines, adding tiny toes to both feet.

8 Continue around the rest of the body and tail's outline. Add fur around the body with curved strokes, with delicate whiskers from the muzzle. Add shading to the tree branch.

9 Start to add colour with light beige and brown tones. Colour the nose a peachy pink.

10 Add some darker tones to create depth. Finish by colouring the tree branch in a brighter brown.

Quokka

Found only in Western Australia, the quokka is about the size of a domestic cat and offers the best exercise in drawing fur.

1 Draw a circle guide for the head. Add a dashed line across the lower half of the circle. Add an oval and a semi-circle on top for the ears.

2 Add an angular shape below for the jaw. Then trace a larger circle below for the chest.

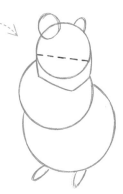

3 Draw another slightly larger circle below the chest, as a guide for the back of the body. Add two shallow ovals for the feet.

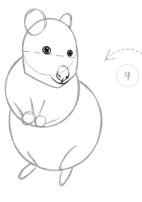

4 Draw the eyes along the horizontal guide, with black pupils and white reflection circles. Add the nose, nostrils and mouth.

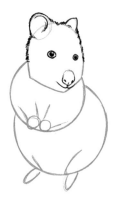

5 Use quick, short strokes around the head and ear shapes to show fur. Add a curve to one ear to show the opening.

6 Continue around the guidelines of the jaw and chest. Add the furry arms and delicate hands. Add dots to show the base of the whiskers.

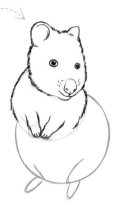

7 Use the remaining circle and shapes to draw the rest of the body and hind legs.

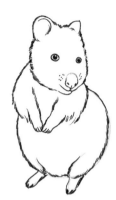

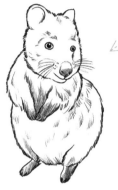

8 Start to add shading to show patches of fur. Position them in a way that emphasizes the plump body. Add long, delicate whiskers.

9 Add a yellow base colour, with a light-brown tone on top. Colour the eyes and nose brown.

10 Add some darker tones to the areas in shadow. Add a darker brown to the feet. Finish with some green grass below.

Emperor tamarin

The long, white beard of the emperor tamarin allegedly gave this monkey its name as it resembles the moustache of the last German emperor, Wilhelm II.

1. Draw a circle for the beard. Add a square-shaped head above, with two small ovals to the side for the ears.

2. Add two curves for the body, and three lines for the tree trunk the tamarin will be sitting on.

3. Sketch curves for the legs, as shown.

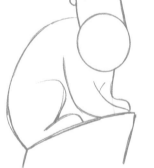

4. Add two curves for the outline of the tail below.

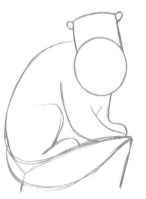

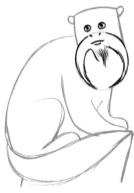

5. Draw the eyes, with tiny, white reflection circles inside. Trace the beard around the edge of the circle using a series of long, curved strokes.

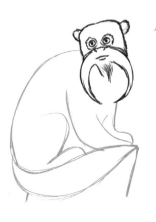

6 Trace the fur around the head and ear guides with a series of quick, short strokes. Add wavy circles around the eyes.

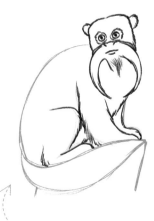

7 Continue with the legs, with longer strokes to show longer hair.

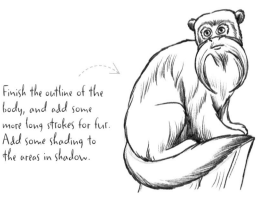

8 Finish the outline of the body, and add some more long strokes for fur. Add some shading to the areas in shadow.

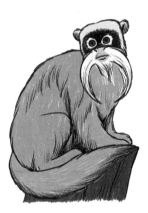

9 Add an olive tone to the body, with a dark-grey mask marking on the face and a bright-orange tail. Colour the top of the head, around the eyes and beard a pale grey. Colour the eyes brown, and the nose and mouth pink.

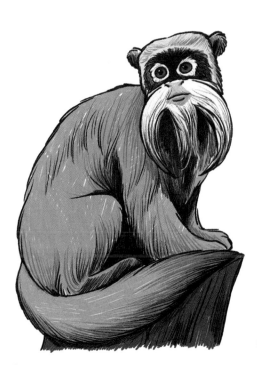

10 Finish with some darker tones throughout the coat.

Red panda

The thick fur and long, bushy tail of the red panda help
it keep warm in the high-altitude forests of Asia.

1. Draw an oval guide for the
head. Add a dashed line
across the centre.

2. Add two triangles for
the ears and a small
circle for the muzzle.

3. Sketch an arc shape to
the right for the body.

38

4. Add two lines for the tree branch below.
Then add two lines for the front legs,
one each side of the branch, and a
long, wavy line for the tail.

5. Draw the shut eyes with two
tiny curves on the guideline.
Add the nose, mouth and
tongue within the muzzle guide.

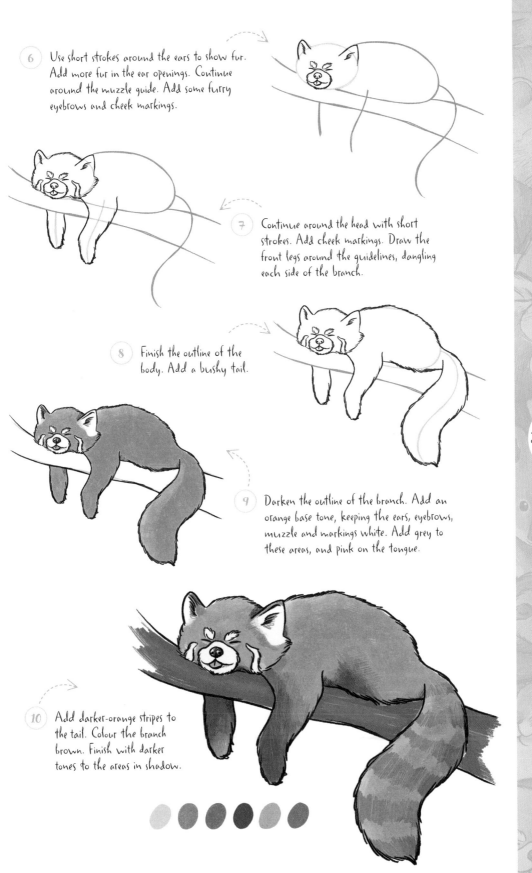

6 Use short strokes around the ears to show fur. Add more fur in the ear openings. Continue around the muzzle guide. Add some furry eyebrows and cheek markings.

7 Continue around the head with short strokes. Add cheek markings. Draw the front legs around the guidelines, dangling each side of the branch.

8 Finish the outline of the body. Add a bushy tail.

9 Darken the outline of the branch. Add an orange base tone, keeping the ears, eyebrows, muzzle and markings white. Add grey to these areas, and pink on the tongue.

10 Add darker-orange stripes to the tail. Colour the branch brown. Finish with darker tones to the areas in shadow.

Margay

This small wild cat from Central and South America has a short, sleek coat with dark-brown, rosette markings. Keep the strokes in the direction of the fur, including when applying the markings.

1. Draw a circle guide for the head. Add a dashed line across the lower half.

2. Add two small ovals for the eyes below the horizontal guide, as shown. Draw two tiny triangles to the bottom left for the nose.

3. Trace two arcs for the ears. Connect the eye and nose to the head circle with a series of short, curved lines, as shown. Erase the part of the circle between these points.

4. Sketch guides for the neck and legs as shown.

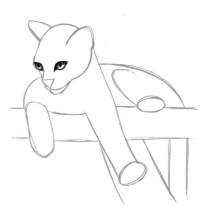

5. Sketch the tree branches. Add curves for the back, tail and hind leg. Draw the eyes, with black pupils and tiny reflection circles.

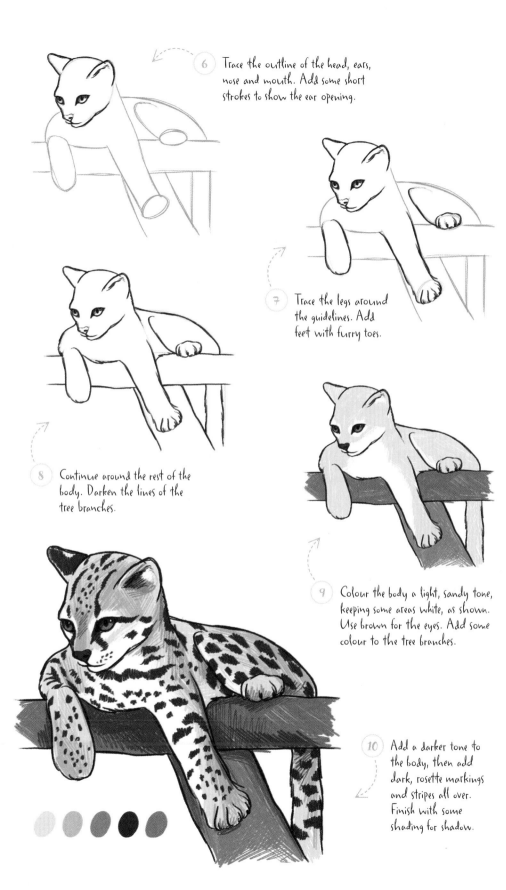

6 Trace the outline of the head, ears, nose and mouth. Add some short strokes to show the ear opening.

7 Trace the legs around the guidelines. Add feet with furry toes.

8 Continue around the rest of the body. Darken the lines of the tree branches.

9 Colour the body a light, sandy tone, keeping some areas white, as shown. Use brown for the eyes. Add some colour to the tree branches.

10 Add a darker tone to the body, then add dark, rosette markings and stripes all over. Finish with some shading for shadow.

Slow loris

The huge, round eyes of this primate from Southeast Asia stand
out even more framed, as they are, in a dark mask marking.

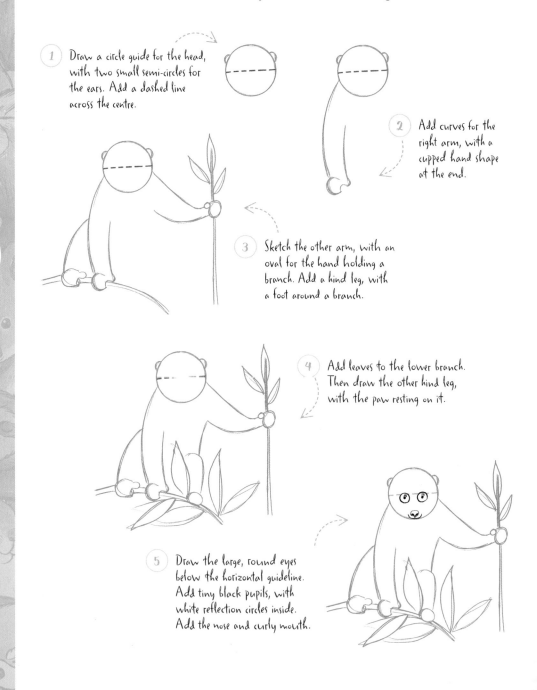

1. Draw a circle guide for the head,
with two small semi-circles for
the ears. Add a dashed line
across the centre.

2. Add curves for the
right arm, with a
cupped hand shape
at the end.

3. Sketch the other arm, with an
oval for the hand holding a
branch. Add a hind leg, with
a foot around a branch.

4. Add leaves to the lower branch.
Then draw the other hind leg,
with the paw resting on it.

5. Draw the large, round eyes
below the horizontal guideline.
Add tiny black pupils, with
white reflection circles inside.
Add the nose and curly mouth.

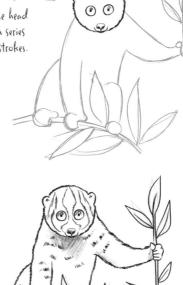

6 Trace around the head and ears with a series of quick, short strokes.

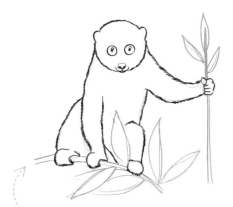

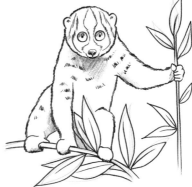

7 Continue tracing the fur along the guidelines of the body.

8 Create a mask marking on the face. Add more fur in short strokes over the body. Add shading to the chest. Darken the outline of the branches.

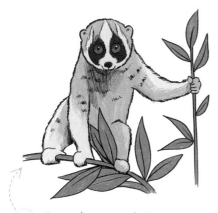

9 Colour the fur using light-brown tones, with dark brown for the mask marking on the face. Add light-brown eyes, and green branches and leaves.

10 Finish with some darker tones to the areas in shade.

Siberian chipmunk

Siberian chipmunks store food in burrows in the winter, using their cheek pouches to transport seeds and nuts.

1 Draw a circle guide for the head. Add an oval and an arc for the ears.

2 Add a U-shape to the lower right for the nose. Add a dashed line through the centre.

3 Sketch guides for the neck and arm, with a circle for the hand.

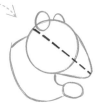

44

4 Draw a small arc for the second hand and two curves between the hands and the nose. Add two curved lines for the body and two ovals for feet. Add a wavy tube shape for the tail.

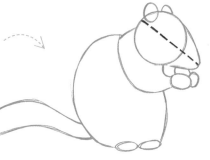

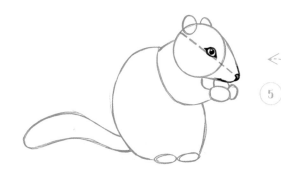

5 Draw the eye on the guideline. Add a black pupil, with a tiny reflection circle inside. Add the nose and mouth inside the nose guide.

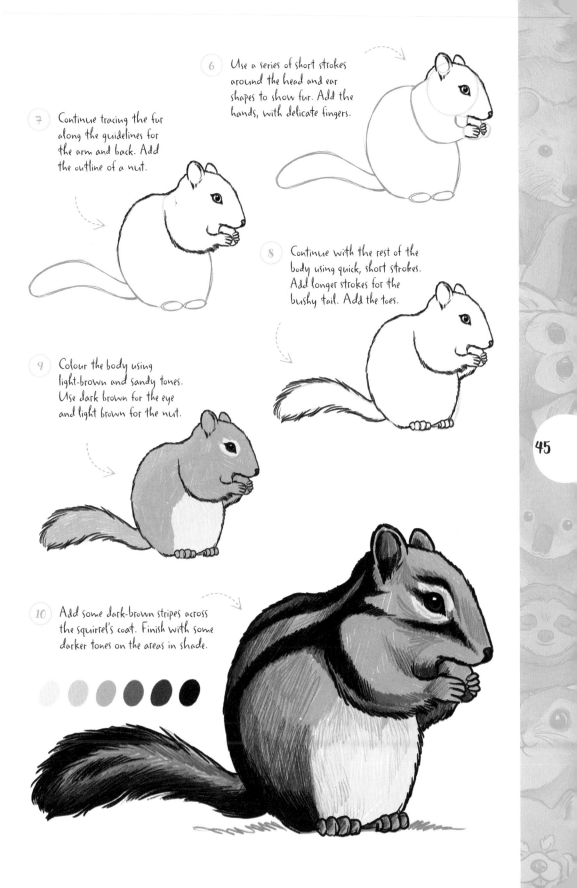

6 Use a series of short strokes around the head and ear shapes to show fur. Add the hands, with delicate fingers.

7 Continue tracing the fur along the guidelines for the arm and back. Add the outline of a nut.

8 Continue with the rest of the body using quick, short strokes. Add longer strokes for the bushy tail. Add the toes.

9 Colour the body using light-brown and sandy tones. Use dark brown for the eye and light brown for the nut.

10 Add some dark-brown stripes across the squirrel's coat. Finish with some darker tones on the areas in shade.

Koala

The koala's large, fluffy ears and spoon-shaped,
leathery nose contrast with its small eyes.

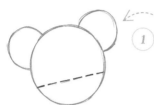

1 Draw a circle guide for the
head. Add a dashed line
across the lower half. Add
two semi-circles for the ears.

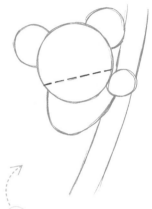

2 Add a line for one arm,
with a circle at the end
for the paw. Sketch two
lines for the branch the
koala is holding onto.

3 Sketch guides for the
koala's other arm, leg
and feet. Notice their
position in relation to
the branch.

4 Draw the small, black
eyes on the guideline,
with tiny, white
reflection circles inside.
Add the spoon-shaped
nose below.

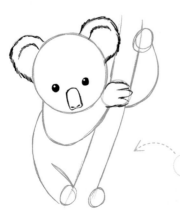

5 Add details of the right paw. Trace
the ears at the top of the head, with
a series of short strokes to show fur.

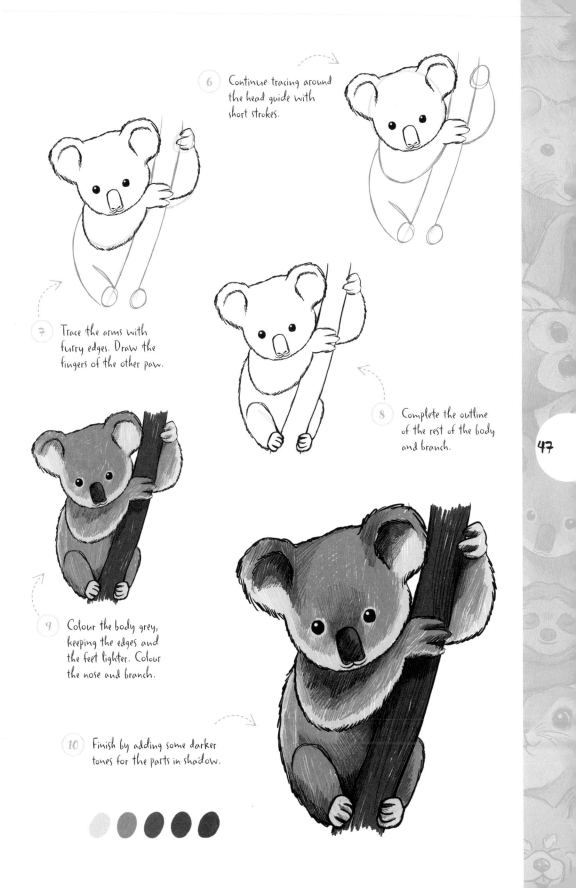

6 Continue tracing around the head guide with short strokes.

7 Trace the arms with furry edges. Draw the fingers of the other paw.

8 Complete the outline of the rest of the body and branch.

9 Colour the body grey, keeping the edges and the feet lighter. Colour the nose and branch.

10 Finish by adding some darker tones for the parts in shadow.

Squirrel monkey

The large eyes of the squirrel monkey are irresistibly endearing when looking straight at you in this pose.

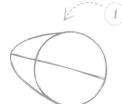

(1) Draw a circle guide for the head. Add a line through the centre and join the end of the line to the circle with two curves to form the jaw.

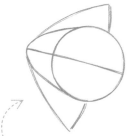

(2) Add two triangles above and below for the ears.

(3) Sketch a straight line for the branch the monkey is hanging from, and four curved lines for the arms.

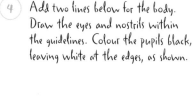

(4) Add two lines below for the body. Draw the eyes and nostrils within the guidelines. Colour the pupils black, leaving white at the edges, as shown.

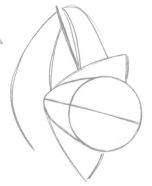

(5) Sketch the curves of the muzzle. Trace around the head guide with a series of very short strokes. Add two curves on the forehead.

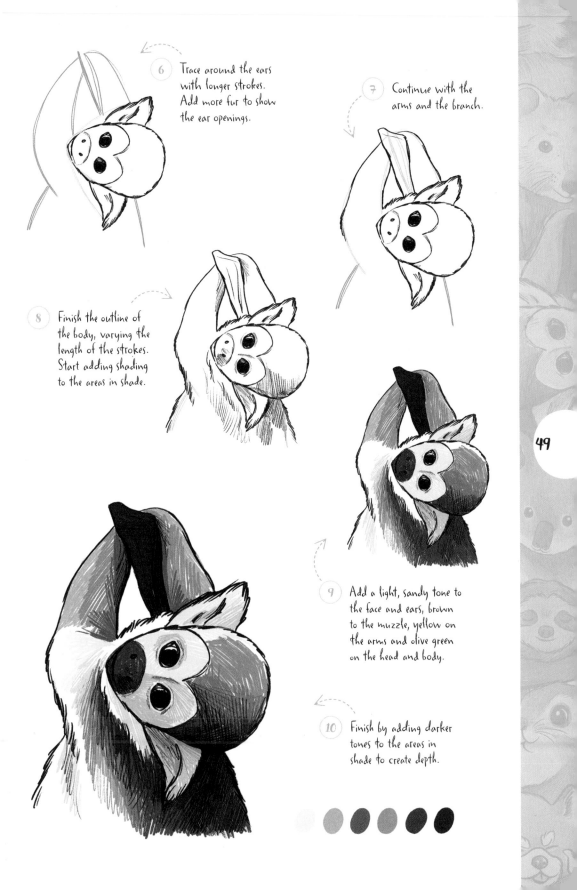

6 Trace around the ears with longer strokes. Add more fur to show the ear openings.

7 Continue with the arms and the branch.

8 Finish the outline of the body, varying the length of the strokes. Start adding shading to the areas in shade.

49

9 Add a light, sandy tone to the face and ears, brown to the muzzle, yellow on the arms and olive green on the head and body.

10 Finish by adding darker tones to the areas in shade to create depth.

Klipspringer

Follow the shapes for the knee and ankle joints to draw
the klipspringer's legs at the correct angles.

1 Draw a circle guide for the head.
Add a dashed line across the
centre. Add an angular U-shape
to the left, below the dashed line,
for the muzzle.

2 Add two arcs
for the ears.

3 Sketch two lines for the
neck and a large oval
for the body.

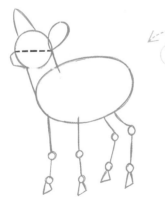

4 Draw lines for the four legs, with
small circles for the knee and ankle
joints, and triangles for the hooves.
Notice the way the hind legs are bent.

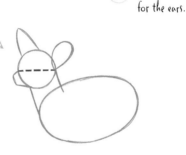

5 Draw the eye along the horizontal
guide, with a tiny reflection circle inside.
Trace the chin and nose around the
guideline, adding the delicate mouth.

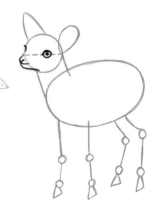

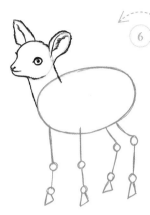

6 Trace the head, ears and neck using a series of short strokes for fur. Add longer fur in the ear openings.

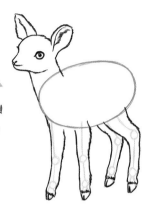

7 Draw the legs around the guidelines, adding delicate cleft hooves.

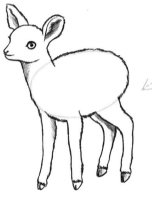

8 Finish tracing the outline of the body with short, furry strokes.

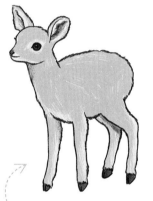

9 Add a light-brown base tone, leaving the ears, around the eyes, the chin, chest and backs of the legs a pale tan.

10 Add some dark-brown and grey markings on the head and ears. Finish with some darker tones for the areas in shade.

Sloth

There's little cuter than a sleeping sloth, which is all sloths do for up to 15 hours a day, hanging from branches as they slowly digest their food.

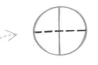

1. Draw a slightly oval circle for the head. Cross it with two lines, as shown.

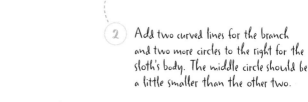

2. Add two curved lines for the branch and two more circles to the right for the sloth's body. The middle circle should be a little smaller than the other two.

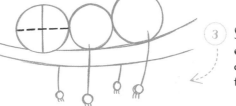

3. Sketch the four legs, with circles at the end for the paws and tiny lines for the claws. Notice their positions in relation to the circles.

4. Add another circle within the head circle. Connect the three main circles with a curved line for the back.

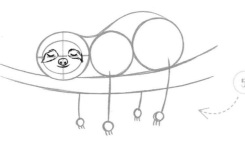

5. Within the inner circle, draw the closed eyes, nose, mouth and mask markings.

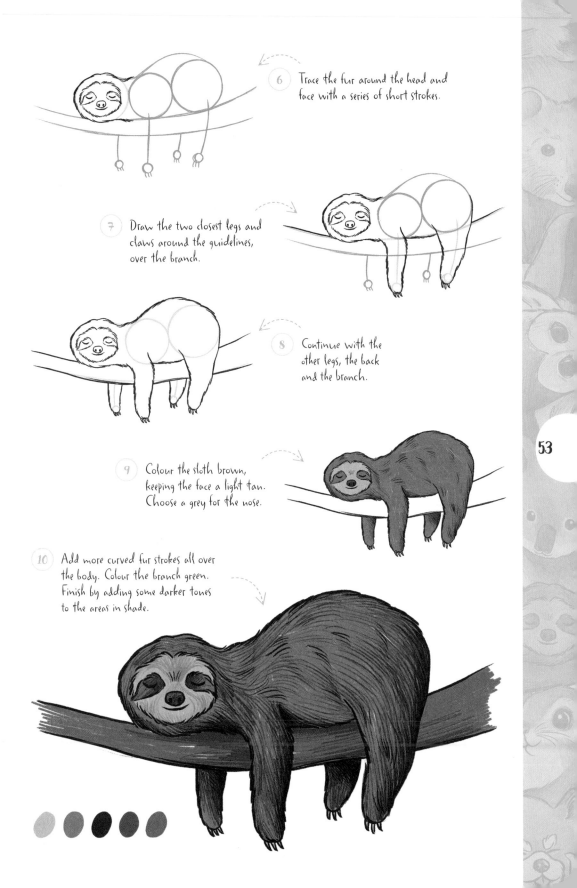

6 Trace the fur around the head and face with a series of short strokes.

7 Draw the two closest legs and claws around the guidelines, over the branch.

8 Continue with the other legs, the back and the branch.

9 Colour the sloth brown, keeping the face a light tan. Choose a grey for the nose.

10 Add more curved fur strokes all over the body. Colour the branch green. Finish by adding some darker tones to the areas in shade.

Okapi

The okapi, or 'forest giraffe', is from the Democratic Republic
of Congo and is the giraffe's only living relative.

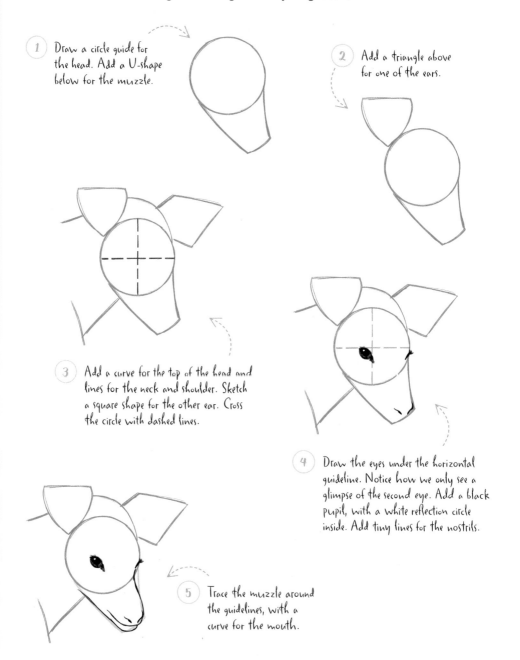

1 Draw a circle guide for
 the head. Add a U-shape
 below for the muzzle.

2 Add a triangle above
 for one of the ears.

3 Add a curve for the top of the head and
 lines for the neck and shoulder. Sketch
 a square shape for the other ear. Cross
 the circle with dashed lines.

4 Draw the eyes under the horizontal
 guideline. Notice how we only see a
 glimpse of the second eye. Add a black
 pupil, with a white reflection circle
 inside. Add tiny lines for the nostrils.

5 Trace the muzzle around
 the guidelines, with a
 curve for the mouth.

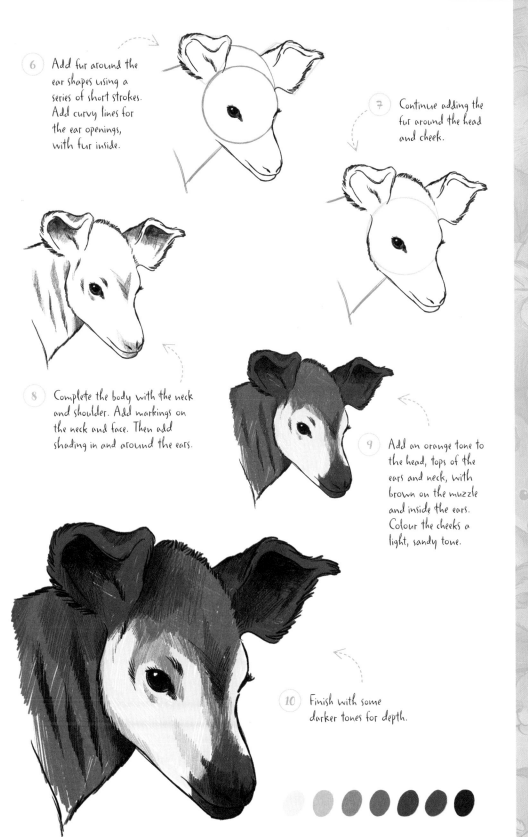

6 Add fur around the ear shapes using a series of short strokes. Add curvy lines for the ear openings, with fur inside.

7 Continue adding the fur around the head and cheek.

8 Complete the body with the neck and shoulder. Add markings on the neck and face. Then add shading in and around the ears.

9 Add an orange tone to the head, tops of the ears and neck, with brown on the muzzle and inside the ears. Colour the cheeks a light, sandy tone.

10 Finish with some darker tones for depth.

Tiger quoll

The tiger quoll is also known as the spotted-tail quoll, because it's the only species of quoll with spots on its tail as well as its body.

1. Draw a circle guide for the head. Add a dashed line across the centre. Add a smaller circle to the bottom right for the nose.

2. Add two small ovals on top for the ears.

3. Sketch a large, circular shape to the left for the body.

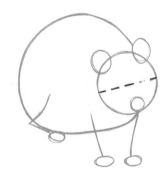

4. Draw lines for three of the legs, with ovals on the end for the paws.

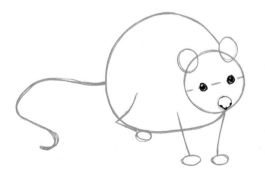

5. Draw the eyes on the horizontal guide. Add black pupils, with reflection circles inside. Add the round nose below and a long, wavy tail.

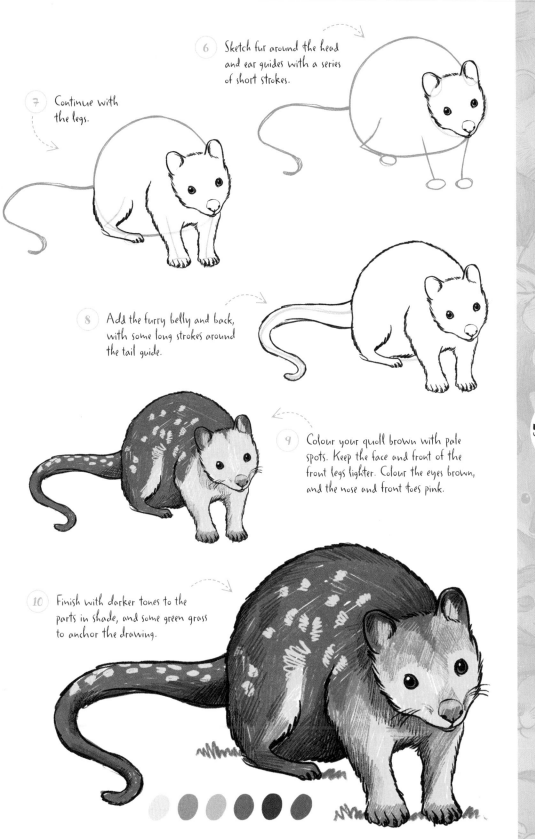

6 Sketch fur around the head and ear guides with a series of short strokes.

7 Continue with the legs.

8 Add the furry belly and back, with some long strokes around the tail guide.

9 Colour your quoll brown with pale spots. Keep the face and front of the front legs lighter. Colour the eyes brown, and the nose and front toes pink.

57

10 Finish with darker tones to the parts in shade, and some green grass to anchor the drawing.

Giant panda

The relatively small size of the giant panda's eyes are accentuated
by the black patch markings that surround them.

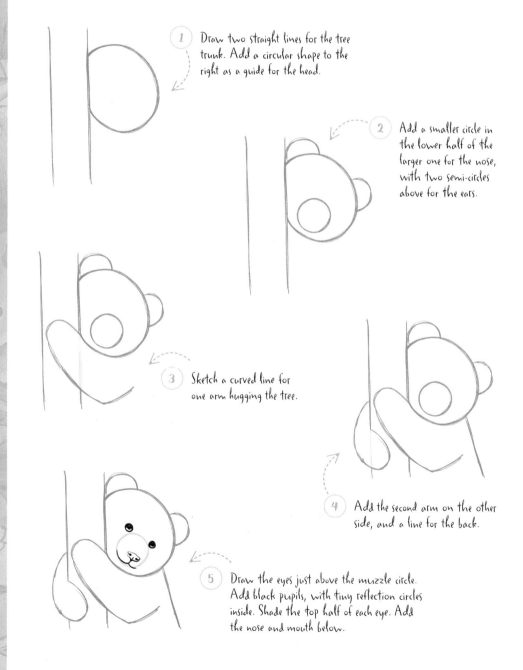

1. Draw two straight lines for the tree trunk. Add a circular shape to the right as a guide for the head.

2. Add a smaller circle in the lower half of the larger one for the nose, with two semi-circles above for the ears.

3. Sketch a curved line for one arm hugging the tree.

4. Add the second arm on the other side, and a line for the back.

5. Draw the eyes just above the muzzle circle. Add black pupils, with tiny reflection circles inside. Shade the top half of each eye. Add the nose and mouth below.

6 Trace around the head and ears using quick, short strokes for fur. Continue with the mask markings around the eyes.

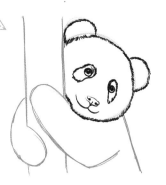

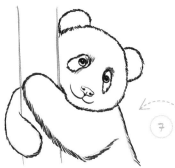

7 Continue with the back and arms.

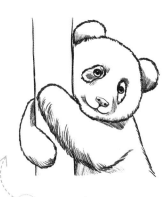

8 Darken the tree trunk and add some shading.

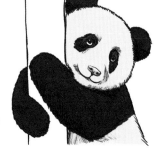

9 Add dark grey or black to the ears, eyes and arms, with a light-beige tone over the face and body.

10 Colour the eyes and tree trunk brown. Finish with some darker tones to the areas in shade.

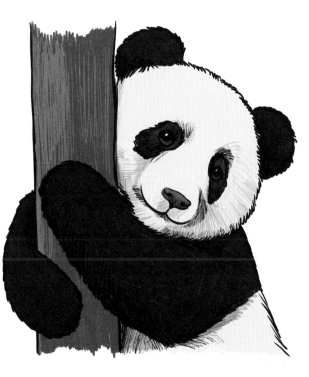

Pika

The rabbit's close relative, the ultra-cute pika is easy
to draw using simple ovals and semi-circles.

1. Draw an oval for the face. Add a
semi-circle to the right for the nose.
Add a dashed line across the centre.

2. Add a bigger semi-circle
to the left for the ear.

3. Sketch a large, oval shape to
the left for the body. This
shape should be about three to
four times the size of the head.

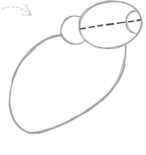

4. Add two ovals underneath
for the feet, and a line for
the rock beneath.

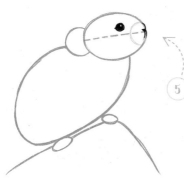

5. Draw the eye above the guideline.
Add a large pupil, with a tiny
reflection circle inside. Add the
delicate nose and mouth below.

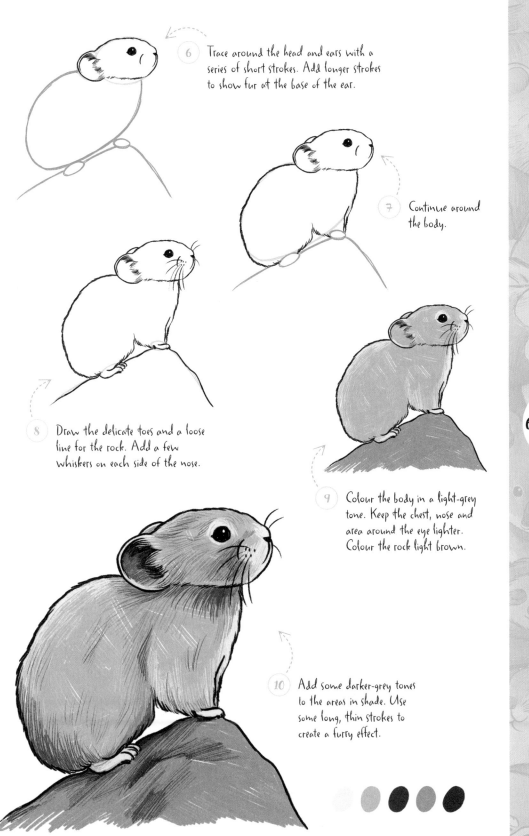

6 Trace around the head and ears with a series of short strokes. Add longer strokes to show fur at the base of the ear.

7 Continue around the body.

8 Draw the delicate toes and a loose line for the rock. Add a few whiskers on each side of the nose.

9 Colour the body in a light-grey tone. Keep the chest, nose and area around the eye lighter. Colour the rock light brown.

10 Add some darker-grey tones to the areas in shade. Use some long, thin strokes to create a furry effect.

Tree frog

The red-eyed tree frog can temporarily stun a predator by opening its eyes suddenly, as they change from green eyelids to bright-red irises.

1. Draw a hexagonal shape as a guide for the head. The lower edge should be a shallow U-shape.

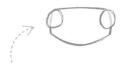

2. Add a small circle on each side for the eyes.

3. Draw a squarish shape below for the body. It should be close to the head without touching it.

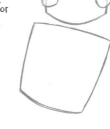

4. Connect the head to the body with two curves. Add a rounded tube shape across the body for the tree branch. For each back foot, draw three short lines on the branch for the toes.

5. Draw the front and back legs. Trace the eyes around the small circle guides. Add the pupils as thin, long slits, with a tiny reflection circle to the side of each.

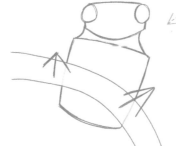

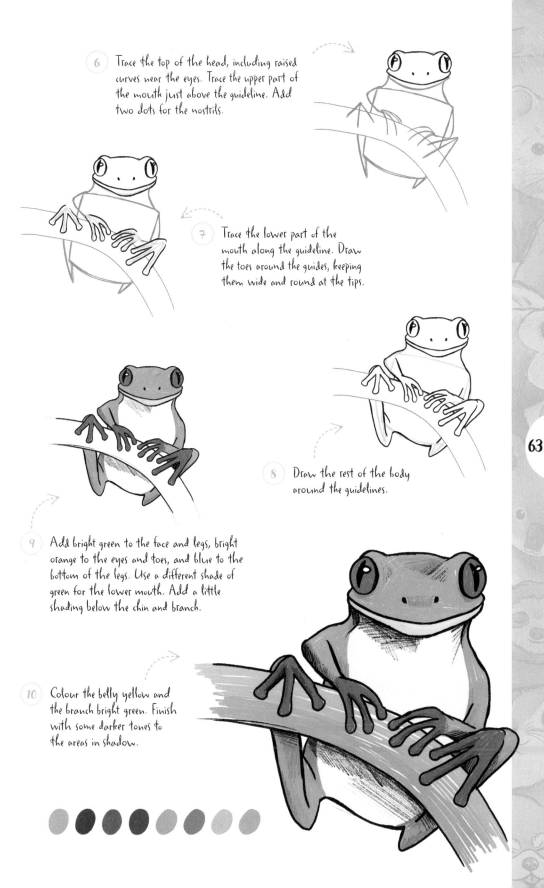

6. Trace the top of the head, including raised curves near the eyes. Trace the upper part of the mouth just above the guideline. Add two dots for the nostrils.

7. Trace the lower part of the mouth along the guideline. Draw the toes around the guides, keeping them wide and round at the tips.

8. Draw the rest of the body around the guidelines.

9. Add bright green to the face and legs, bright orange to the eyes and toes, and blue to the bottom of the legs. Use a different shade of green for the lower mouth. Add a little shading below the chin and branch.

10. Colour the belly yellow and the branch bright green. Finish with some darker tones to the areas in shadow.

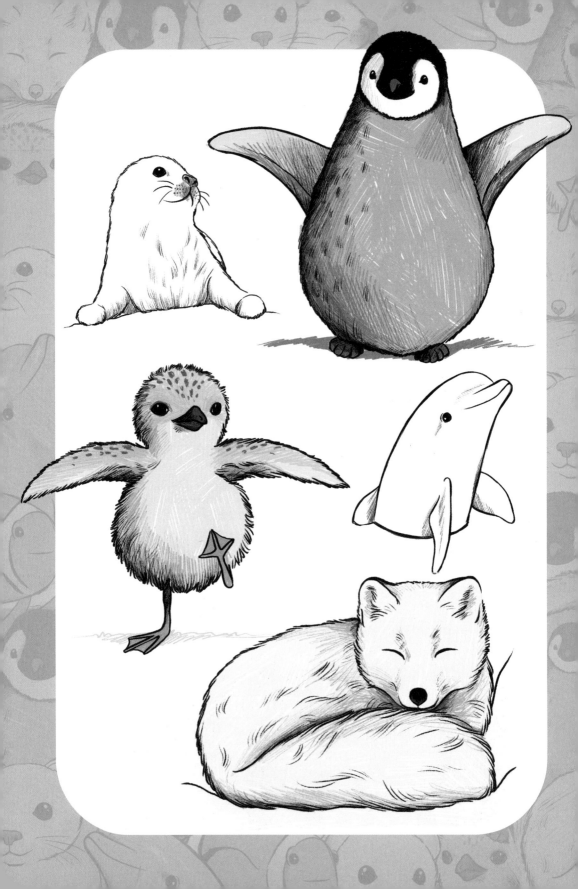

Arctic & Oceans

Arctic fox

The thick, white fur of the arctic fox provides camouflage. It also prevents
heat loss, as the hollow white fur shafts trap warm air from the body.

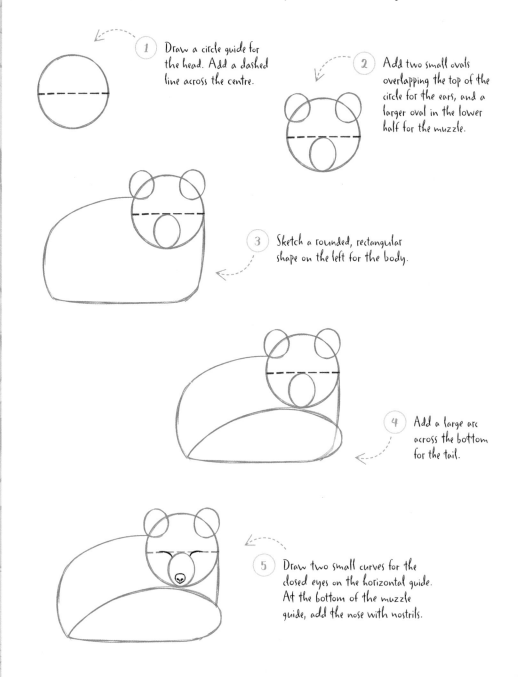

1 Draw a circle guide for the head. Add a dashed line across the centre.

2 Add two small ovals overlapping the top of the circle for the ears, and a larger oval in the lower half for the muzzle.

3 Sketch a rounded, rectangular shape on the left for the body.

4 Add a large arc across the bottom for the tail.

5 Draw two small curves for the closed eyes on the horizontal guide. At the bottom of the muzzle guide, add the nose with nostrils.

6 Trace around the furry ears with a series of short strokes. Add longer fur to the ear openings.

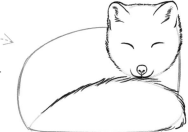

7 Continue around the head and face. Add longer strokes around the top of the tail guide.

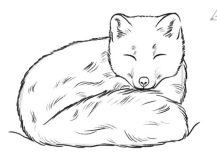

8 Continue with the rest of the body, varying the direction of the strokes. Add wavy strokes across the coat for an extra-furry effect.

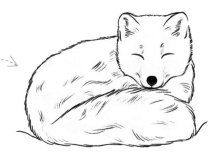

9 Add a light, sandy base tone, with black to the nose.

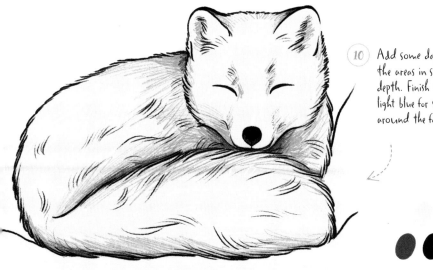

10 Add some darker tones to the areas in shade to create depth. Finish with some light blue for snow all around the fox.

Penguin

With soft, downy feathers and a waddling walk, plump
penguin chicks are the ultimate in cute!

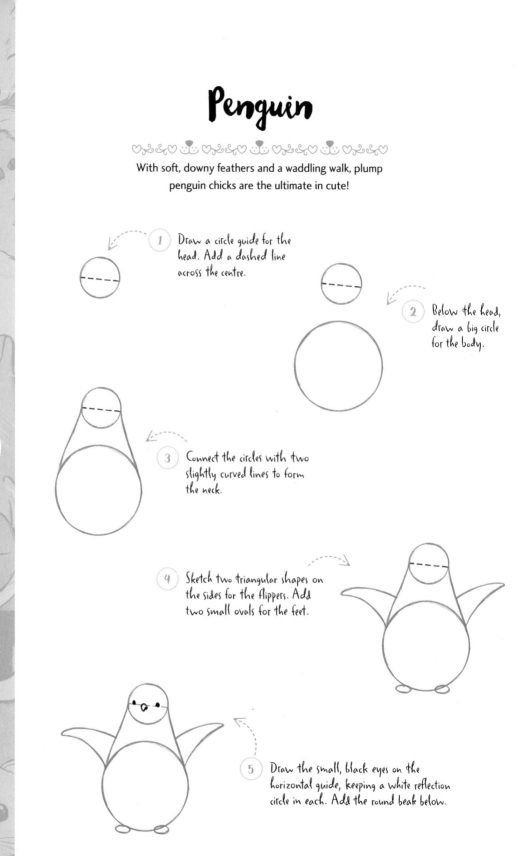

1. Draw a circle guide for the
head. Add a dashed line
across the centre.

2. Below the head,
draw a big circle
for the body.

3. Connect the circles with two
slightly curved lines to form
the neck.

4. Sketch two triangular shapes on
the sides for the flippers. Add
two small ovals for the feet.

5. Draw the small, black eyes on the
horizontal guide, keeping a white reflection
circle in each. Add the round beak below.

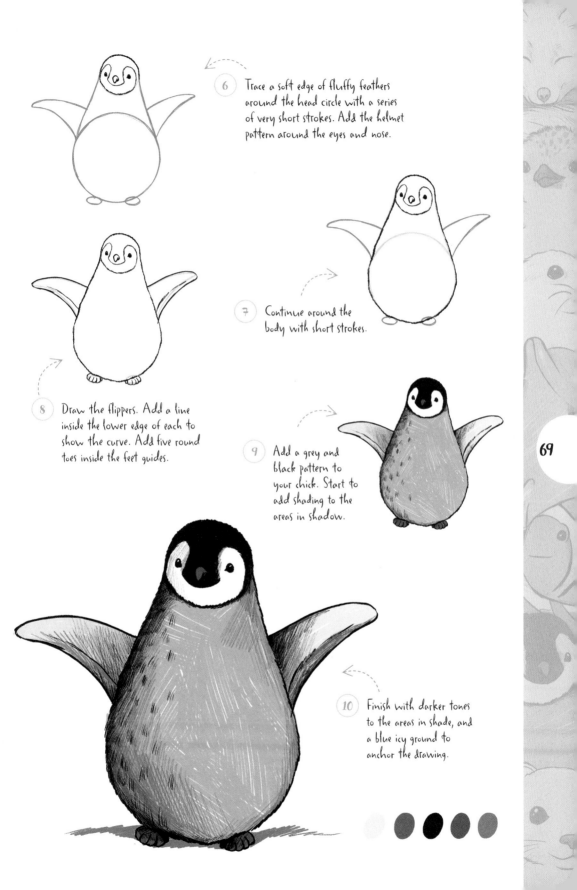

6 Trace a soft edge of fluffy feathers around the head circle with a series of very short strokes. Add the helmet pattern around the eyes and nose.

7 Continue around the body with short strokes.

8 Draw the flippers. Add a line inside the lower edge of each to show the curve. Add five round toes inside the feet guides.

9 Add a grey and black pattern to your chick. Start to add shading to the areas in shadow.

10 Finish with darker tones to the areas in shade, and a blue icy ground to anchor the drawing.

Seal

For the first two weeks of their lives, seal pups have a thick, white coat, before grey spots begin to appear after their first moult.

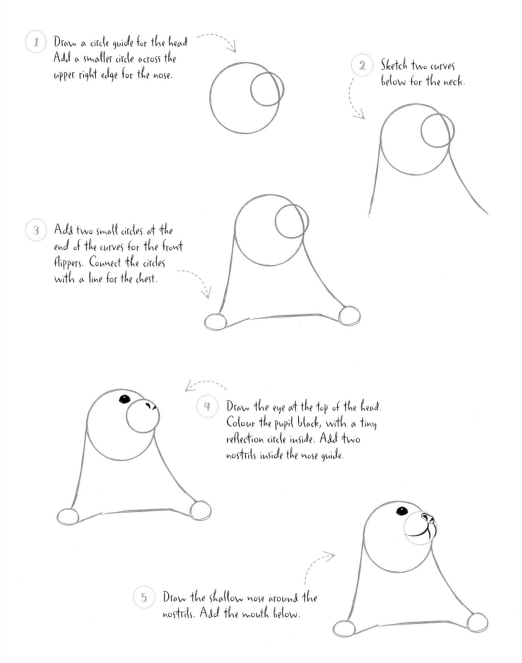

1 Draw a circle guide for the head. Add a smaller circle across the upper right edge for the nose.

2 Sketch two curves below for the neck.

3 Add two small circles at the end of the curves for the front flippers. Connect the circles with a line for the chest.

4 Draw the eye at the top of the head. Colour the pupil black, with a tiny reflection circle inside. Add two nostrils inside the nose guide.

5 Draw the shallow nose around the nostrils. Add the mouth below.

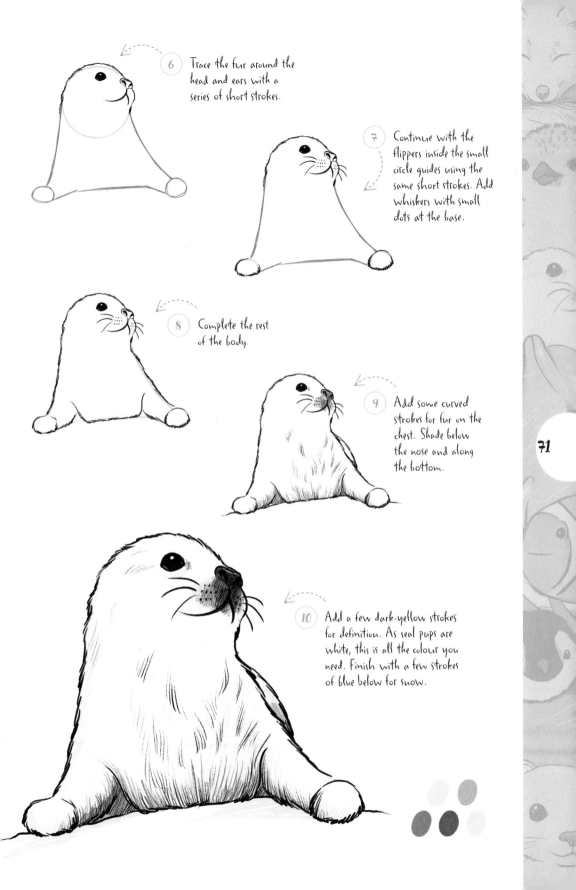

6 Trace the fur around the head and ears with a series of short strokes.

7 Continue with the flippers inside the small circle guides using the same short strokes. Add whiskers with small dots at the base.

8 Complete the rest of the body.

9 Add some curved strokes for fur on the chest. Shade below the nose and along the bottom.

71

10 Add a few dark-yellow strokes for definition. As seal pups are white, this is all the colour you need. Finish with a few strokes of blue below for snow.

Dolphin

The dolphin's skin is so smooth that light bounces off it.
Try to capture this texture using straight strokes.

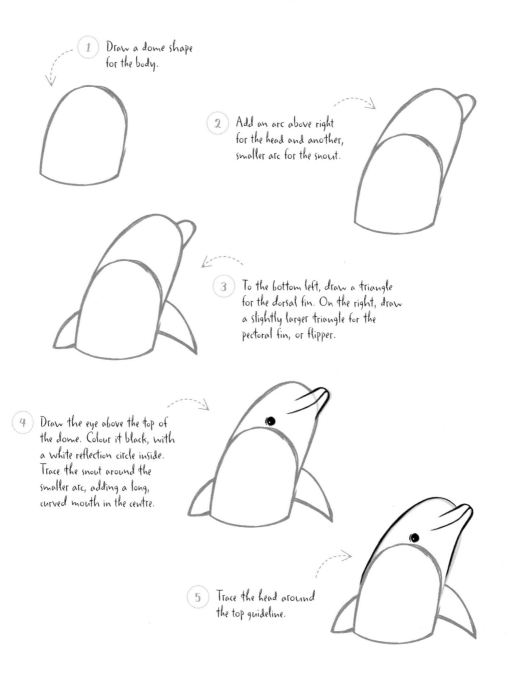

1 Draw a dome shape for the body.

2 Add an arc above right for the head and another, smaller arc for the snout.

3 To the bottom left, draw a triangle for the dorsal fin. On the right, draw a slightly larger triangle for the pectoral fin, or flipper.

4 Draw the eye above the top of the dome. Colour it black, with a white reflection circle inside. Trace the snout around the smaller arc, adding a long, curved mouth in the centre.

5 Trace the head around the top guideline.

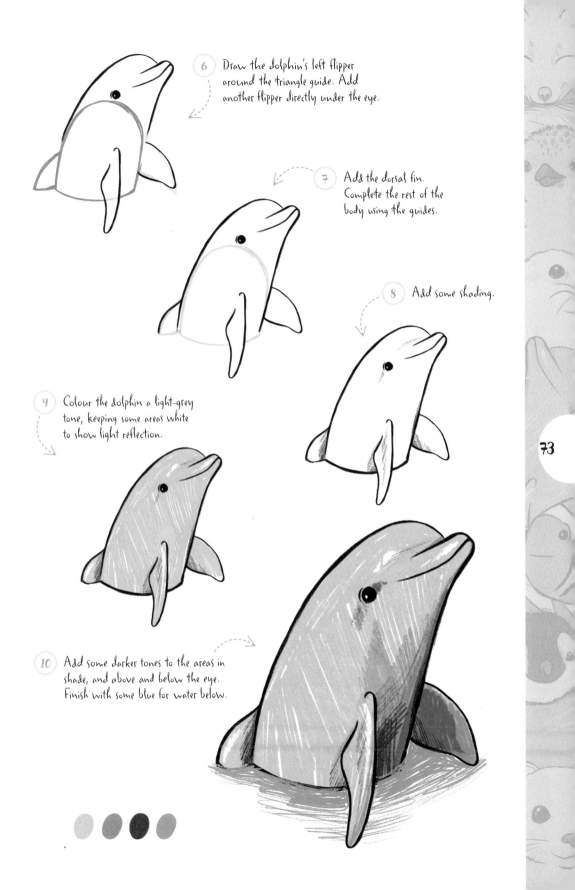

6 Draw the dolphin's left flipper around the triangle guide. Add another flipper directly under the eye.

7 Add the dorsal fin. Complete the rest of the body using the guides.

8 Add some shading.

9 Colour the dolphin a light-grey tone, keeping some areas white to show light reflection.

10 Add some darker tones to the areas in shade, and above and below the eye. Finish with some blue for water below.

73

Least tern

The chicks of the least tern are covered in yellowy-tan down,
which blends in well with their nests on sandy beaches.

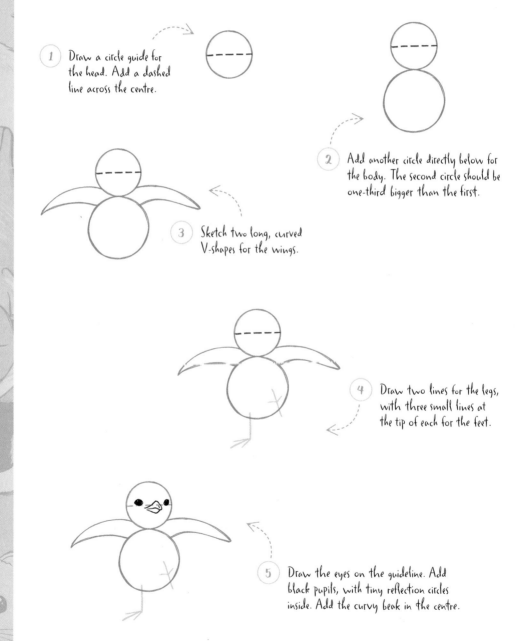

1 Draw a circle guide for the head. Add a dashed line across the centre.

2 Add another circle directly below for the body. The second circle should be one-third bigger than the first.

3 Sketch two long, curved V-shapes for the wings.

4 Draw two lines for the legs, with three small lines at the tip of each for the feet.

5 Draw the eyes on the guideline. Add black pupils, with tiny reflection circles inside. Add the curvy beak in the centre.

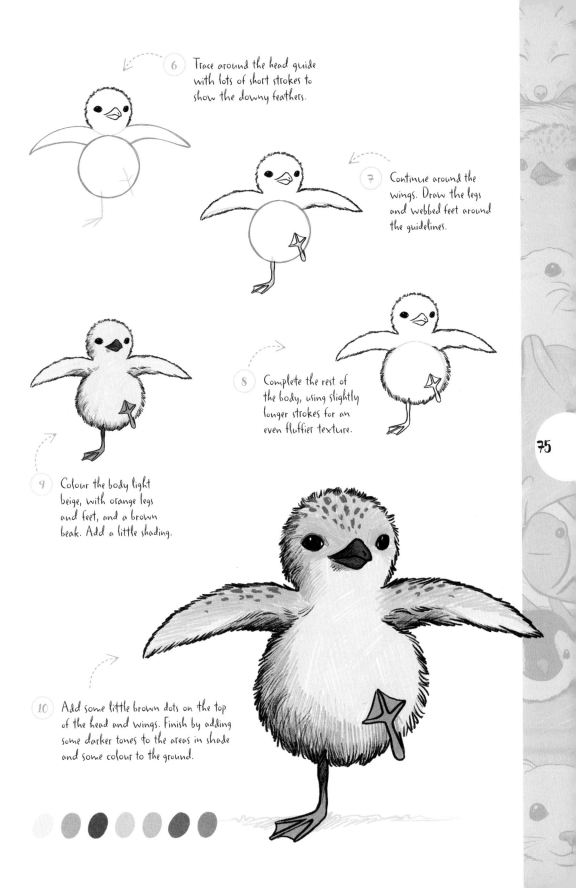

6 Trace around the head guide with lots of short strokes to show the downy feathers.

7 Continue around the wings. Draw the legs and webbed feet around the guidelines.

8 Complete the rest of the body, using slightly longer strokes for an even fluffier texture.

9 Colour the body light beige, with orange legs and feet, and a brown beak. Add a little shading.

10 Add some little brown dots on the top of the head and wings. Finish by adding some darker tones to the areas in shade and some colour to the ground.

Ermine

Looking at the pure-white winter coat of the ermine, or stoat,
you wouldn't believe it turns brown in the summer months.

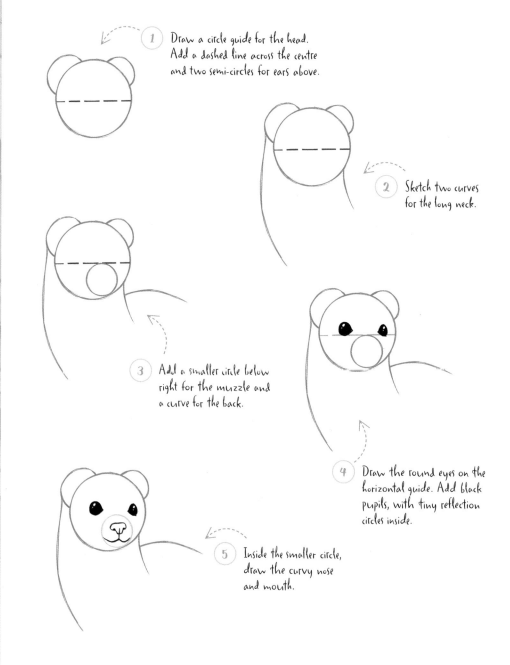

1 Draw a circle guide for the head.
 Add a dashed line across the centre
 and two semi-circles for ears above.

2 Sketch two curves
 for the long neck.

3 Add a smaller circle below
 right for the muzzle and
 a curve for the back.

4 Draw the round eyes on the
 horizontal guide. Add black
 pupils, with tiny reflection
 circles inside.

5 Inside the smaller circle,
 draw the curvy nose
 and mouth.

76

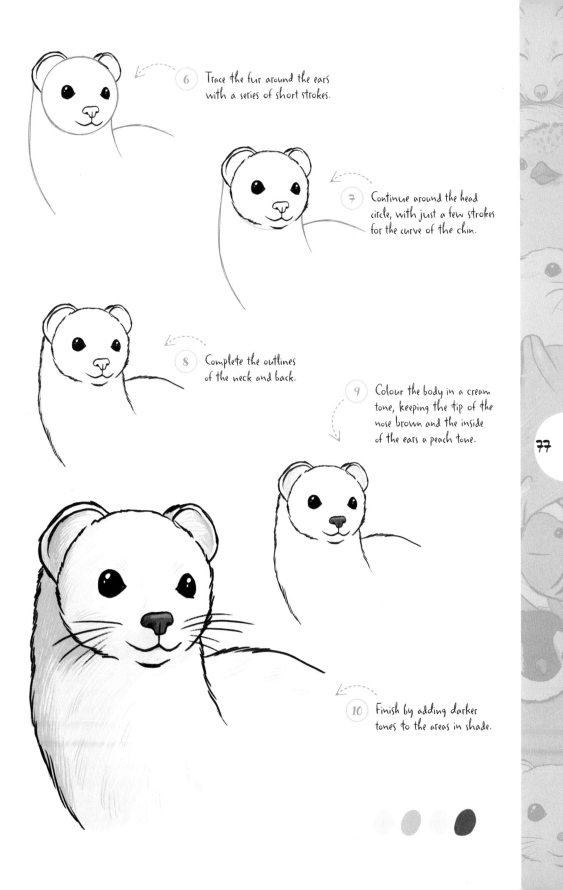

6 Trace the fur around the ears with a series of short strokes.

7 Continue around the head circle, with just a few strokes for the curve of the chin.

8 Complete the outlines of the neck and back.

9 Colour the body in a cream tone, keeping the tip of the nose brown and the inside of the ears a peach tone.

10 Finish by adding darker tones to the areas in shade.

Clownfish

An explosion of colour marks this favourite tropical fish, made famous by a Disney's *Finding Nemo*. Fins are easy if you follow the semi-circular guides.

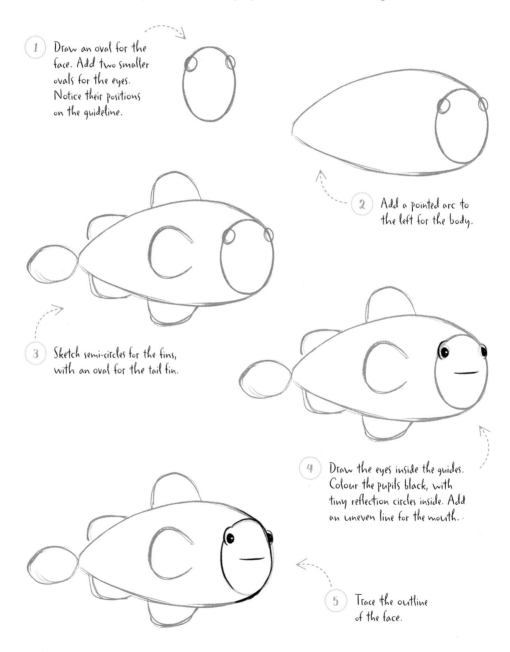

1 Draw an oval for the face. Add two smaller ovals for the eyes. Notice their positions on the guideline.

2 Add a pointed arc to the left for the body.

3 Sketch semi-circles for the fins, with an oval for the tail fin.

4 Draw the eyes inside the guides. Colour the pupils black, with tiny reflection circles inside. Add an uneven line for the mouth.

5 Trace the outline of the face.

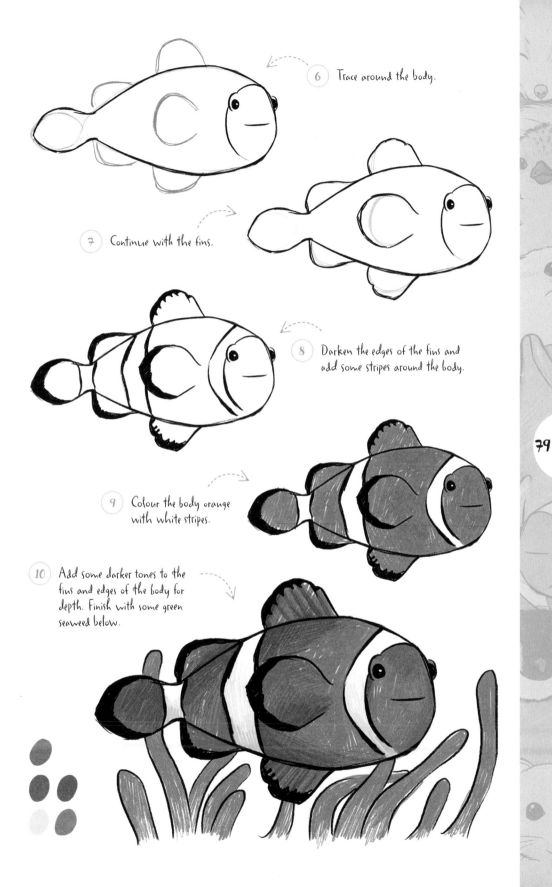

6 Trace around the body.

7 Continue with the fins.

8 Darken the edges of the fins and add some stripes around the body.

9 Colour the body orange with white stripes.

10 Add some darker tones to the fins and edges of the body for depth. Finish with some green seaweed below.

Sea otter

The sea otter has the thickest fur of any living animal. Without the blubber of other sea animals, the fur is all that keeps this creature warm.

1 Draw an irregular oblong for the head. Add a circle in the centre for the nose. Add a dashed line just above this to help position the eyes.

2 Add two small curves for the ears. Sketch a long, curved line for the arm.

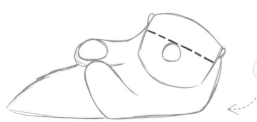

3 Sketch the upper arm, with an oval for the paw. Add a V-shape for the part of the body on top of the water.

4 Draw the eyes above the horizontal guide. Add black pupils, with tiny reflection circles inside. Add the curved nose below.

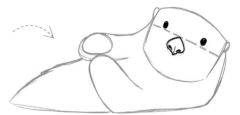

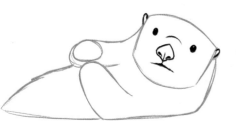

5 Add the mouth below, with a little line up to join the nose. Sketch a curve above the nose to show the end of the snout.

6 Use quick, short strokes around the head and ear shapes to show fur. Vary the shape and size of each stroke to look more natural.

7 Continue around the arms and paw.

8 Finish the outline of the body and add some long whiskers.

9 Colour the body light brown, with a dark-brown nose and eyes.

10 Apply darker tones to show the areas in shadow. Finish with some blue below for the water.

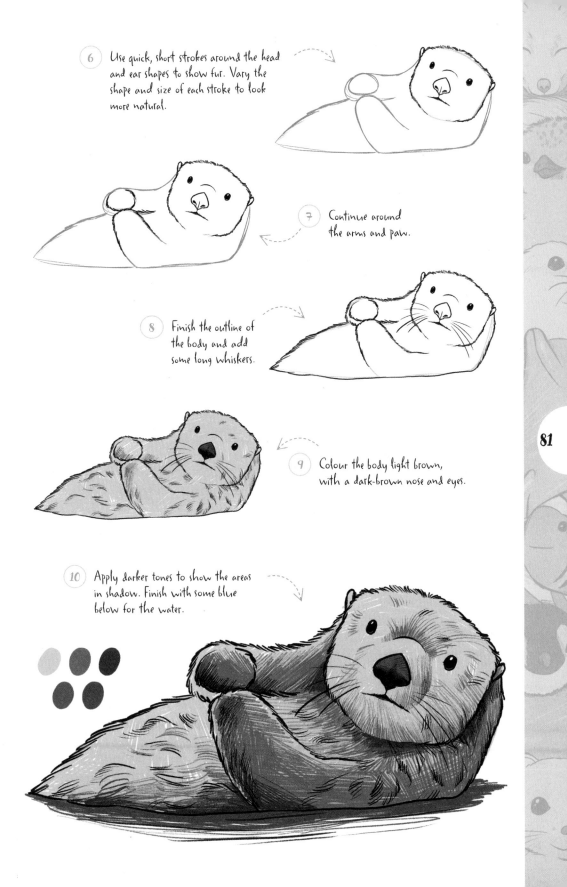

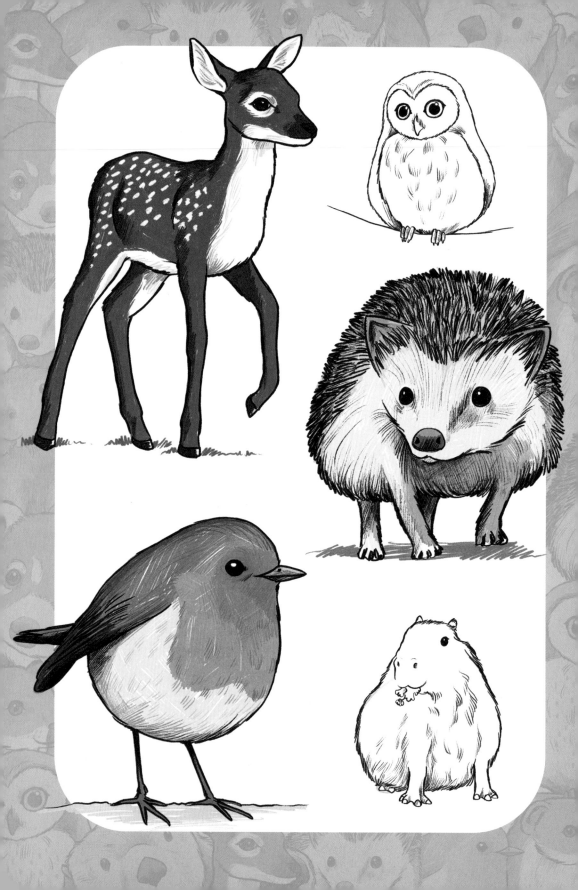

Woodlands & Wetlands

Owl

It's all about oval shapes when drawing this owl, from
the head and tummy to the enormous, yellow eyes.

1 Draw an oval for the head.
Cross it with two slightly
curved lines. These will help
position the eyes and beak.

2 Add another oval directly
below for the body. This
should be twice the size of
the head circle.

3 Connect the head and
body with two curves
to form the neck.

4 Add two small circles at the
bottom for the feet. Trace lines
on each side for the branch.

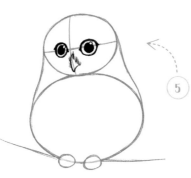

5 Draw the large eyes on the horizontal guideline,
including black pupils and tiny reflection circles inside.
Make the eye on the left slightly smaller because of
perspective. Add a triangular beak below, with short
strokes for tiny feathers on the sides.

6 Sketch the owl's heart-shaped face inside the head circle, using quick, short strokes to show feathers.

7 Continue around the the head and body. Add the branch and the feet, with three toes and tiny claws.

8 Use longer strokes for the outline of the chest, with feathery curves on the chest and above the face. Start to add shading.

9 Colour the body in two shades of brown, with a dark-brown beak and legs. Add bright yellow to the eyes.

10 Add some brown spots to the chest. Finish with darker tones for definition and some green on the branch below.

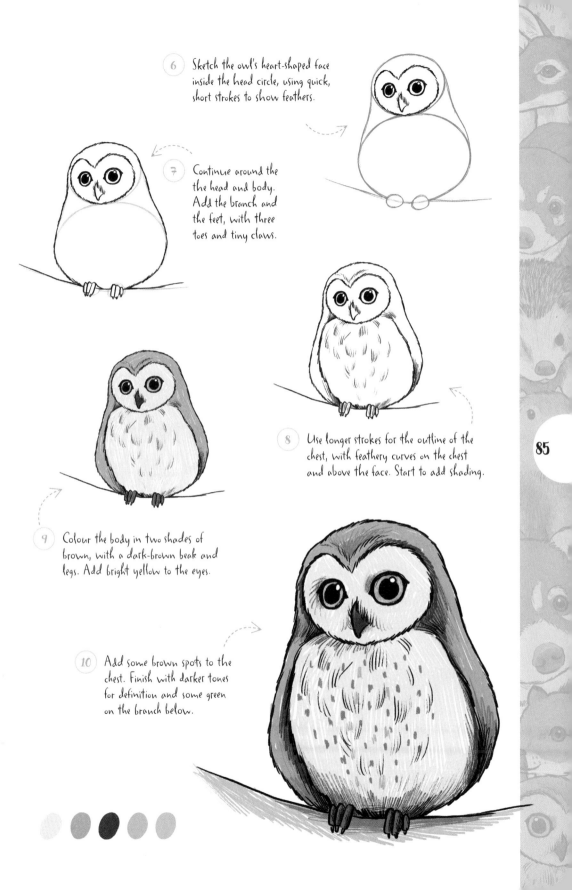

Fawn

The 1942 film *Bambi* brought fawns to the top of the cute list.
Drawing the spindly legs is easy if you follow the guides.

1 Draw a circle for the head. Add a dashed line across the centre. Trace a U-shape to the right for the muzzle.

2 Add another circle below left. The distance between the two circles should be the same as the diameter of the smaller circle. Add ear shapes at the top.

3 Connect the two circles with lines for the neck. Add a U-shape to the left of the body.

4 Draw lines for the legs, with circles for the knee and ankle joints, and triangles for the hooves.

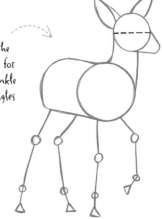

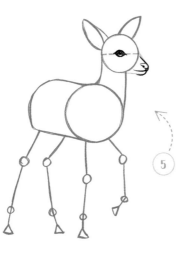

5 Draw the eye on the guideline. Add a black pupil, with a reflection circle inside. Trace the nose and chin around the muzzle guide, adding a curve for the mouth.

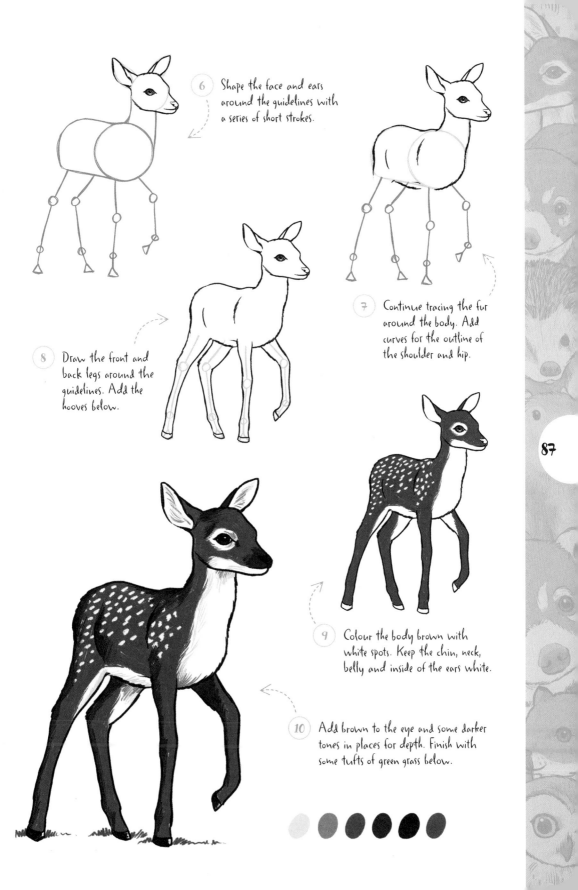

6 Shape the face and ears around the guidelines with a series of short strokes.

7 Continue tracing the fur around the body. Add curves for the outline of the shoulder and hip.

8 Draw the front and back legs around the guidelines. Add the hooves below.

9 Colour the body brown with white spots. Keep the chin, neck, belly and inside of the ears white.

10 Add brown to the eye and some darker tones in places for depth. Finish with some tufts of green grass below.

Hedgehog

The hedgehog's stiff spines contrast with the soft fur on its face and belly.
Experiment with your strokes to get these textures just right.

1 Draw a circle for the head. Add a dashed line across the centre and a smaller circle to the bottom left for the nose.

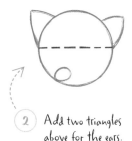

2 Add two triangles above for the ears.

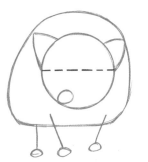

3 Sketch an irregular oblong around the head for the body. Draw three lines for the legs, with small ovals at the end for the feet.

4 Draw the round eyes below the guideline. The eye on the left should be slightly smaller because of perspective. Add the nose below.

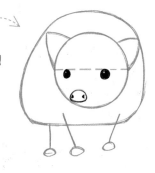

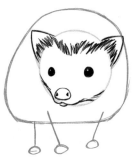

5 Trace the outline of the ears. Then add a series of upright strokes around the forehead for the spines. Draw the outline of the chin and mouth.

6 Trace the spines all around the body with a series of strokes.

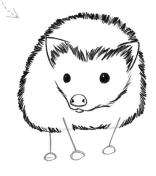

7 Sketch the legs around the guidelines, with small, curves for the toes. Add a short line to show the fourth leg behind the front leg.

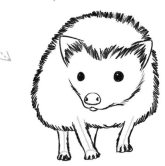

8 Add more spines across the back and sides. Use finer strokes on the face, chest and legs to show fur.

9 Colour the body in two tones of beige. Add brown to the ears and nose.

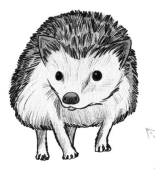

10 Add some darker tones to the areas in shadow. Finish with some brown strokes for the ground below.

Capybara

The capybara's ears, eyes and nostrils are towards the top of its head so it can breathe and look around while remaining mostly underwater. Use the guides to help get these right.

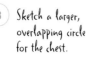

1. Draw a circle for the head. Add a wide U-shape to the lower left for the snout.

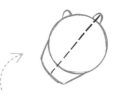

2. Add a dashed line through the centre, breaking through the top of the circle a little. Add two small semi-circles for the ears. One should be around the end of the dashed line. The other should be smaller because of perspective.

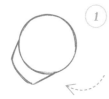

3. Sketch a larger, overlapping circle for the chest.

4. Connect the head to the chest with a curve for the neck. Add an arc to the left for the body. Draw two lines for the front legs, with ovals at the end for the feet. Add a smaller oval behind for the back foot.

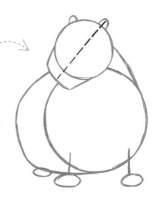

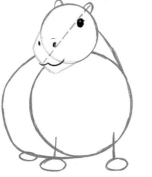

5. Draw the eye to the upper right of the guideline. Colour the pupil black, with a tiny reflection circle inside. Add the nostrils and a wavy mouth below.

6 Under the mouth, sketch some curly leaves and a flower. Trace around the head and ear guides with a series of strokes for fur.

7 Continue tracing around the neck and body. Draw the front legs around the guidelines, adding little round toes.

8 Complete the outline of the body and add toes to the back foot. Add a little shading to the areas in shadow.

9 Add a light-brown base tone, with some grey to the nose and toes. Colour the leaves and flower.

10 Finish with darker tones to create depth and some brown strokes for the ground below.

91

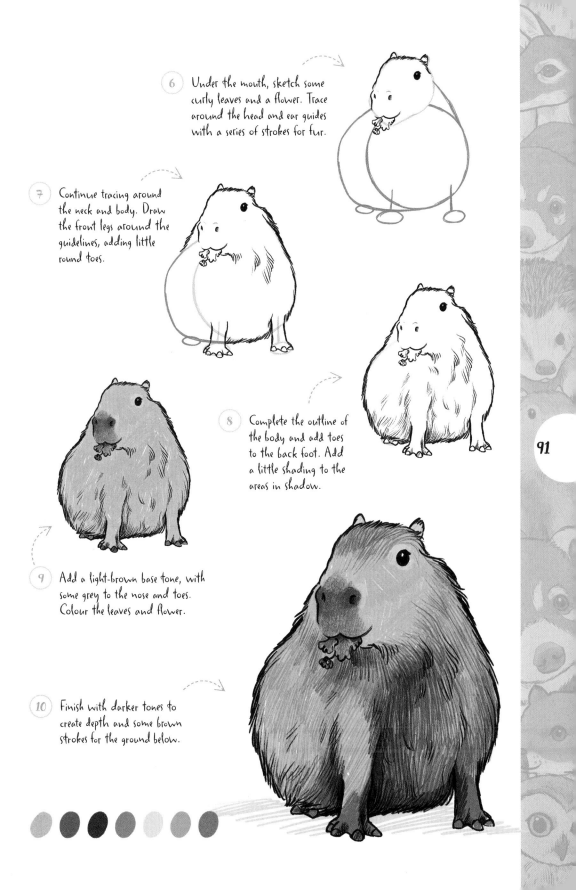

Beaver

The beaver's hand-like front feet, used to grip food,
couldn't be more different to its large, webbed hind feet.

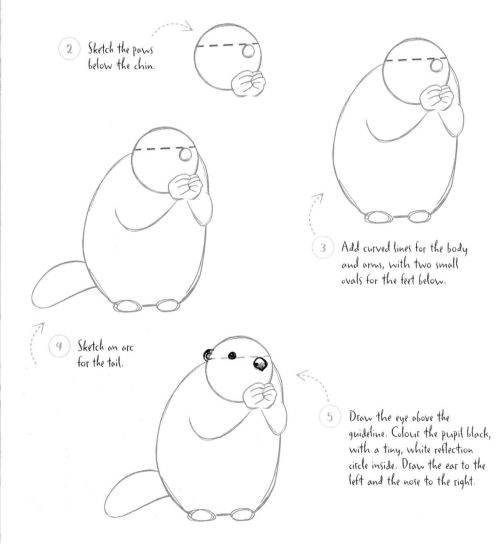

1. Draw a circle for the head. Add a dashed line across the upper half. Draw a smaller circle just under the guideline to the right for the nose.

2. Sketch the paws below the chin.

3. Add curved lines for the body and arms, with two small ovals for the feet below.

4. Sketch an arc for the tail.

5. Draw the eye above the guideline. Colour the pupil black, with a tiny, white reflection circle inside. Draw the ear to the left and the nose to the right.

6 Add a curve down from the nose and the mouth below. Trace the hands.

7 Trace the fur around the head, cheeks and arms with a series of strokes. Vary the length of each stroke to show the uneven fur.

8 Continue around the body and tail, adding a short curve in the tail's centre and long strokes for whiskers. Add the webbed feet below.

9 Colour the body brown, keeping the muzzle and hands lighter. Use a burgundy colour for the feet, nose and tail.

10 Finish with some darker tones for the areas in the shade, and some green ground below.

Japanese weasel

Getting the proportions of the weasel's long, slender body is easy
if you get the planning right. Notice the relative shapes and
distances of each circle as you plot their positions.

1 Draw a circle for the head.
Add two semi-circles for
the ears, with one much
smaller than the other to
show perspective.

2 Add another circle to the lower
left for the shoulders. The
distance between the two circles
should be about the same as the
diameter of the head circle.

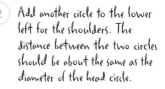

3 Connect the two circles with curved lines for
the neck. Add a third, overlapping circle to
the left for the hips. This circle should be
slightly larger than the second one.

4 Connect the second and third circles for the
back and belly. Draw two lines for the
front legs, with circles and ovals for feet.
Draw a dashed line across the head circle.

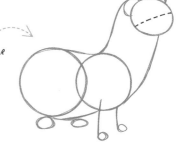

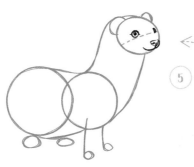

5 Draw the eyes above the guideline. The
furthest eye is just a tiny semi-circle. Colour
the pupil black, with a tiny reflection circle
inside. Add the nose and mouth below.

94

6 Shape the face and ears around the guidelines using a series of short strokes for fur.

7 Continue around the neck and body.

8 Draw the legs and feet. Finish the outline of the body, add a curved line for the tail and whiskers on the face.

9 Colour the body, legs and tail light brown, leaving the chin, neck and belly white. Add a darker brown to the nose.

10 Add some darker tones through the fur and in the areas in shade. Finish with some green for the ground below.

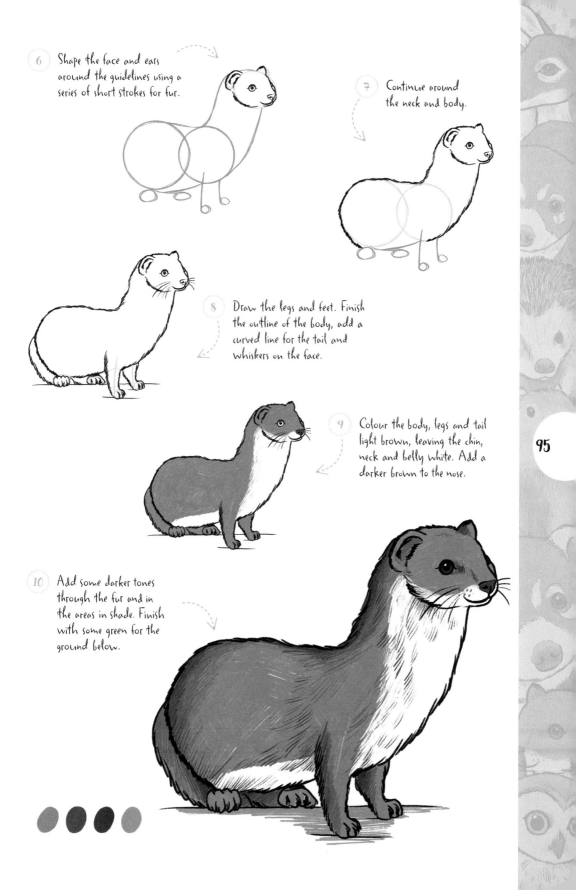

White—nosed coati

The size of a large house cat, the white-nosed coati can use its strong claws to climb down trees backwards.

① Draw a circle for the head. Add a dashed line across the centre. Sketch two arcs above for the ears.

② Add a smaller circle at the bottom for the nose. Sketch guides for the front legs under the head circle, with circles for the feet.

③ Draw lines for the hips, back leg and chest, with a semi-circle for the hind foot.

④ Draw the round eyes under the guideline, with curvy eyebrows above. Colour the pupils black, with tiny reflection circles to the top of each. Add the nose below.

⑤ Trace the fur around the head, ears and snout with a series of short strokes, with longer lines for the fur inside the ears.

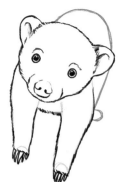

6 Continue tracing around the legs and chest. Draw five long claws on each front foot.

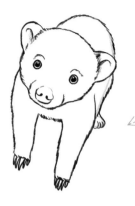

7 Complete the rest of the body and back foot, using quick, short strokes.

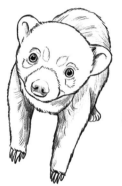

8 Add some markings to the face and shade the areas in shadow.

9 Colour the body brown, with paler ears, chest and face markings. Add dark-brown eyes, light-brown claws and a grey nose.

10 Add some darker tones over the face and shaded areas, and finish with some grey for the ground.

European robin

The European robin, or robin redbreast, is a favourite songbird in gardens across Europe, with its red face and plump breast.

1. Draw a circle for the body. Add a smaller, overlapping circle above right for the head.

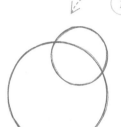

2. To the right of the head circle, draw two triangles for the beak. Sketch two curved lines to the left for the wing.

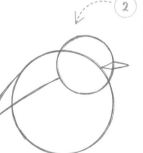

3. Sketch two lines for the legs, with four short lines at the end for the toes.

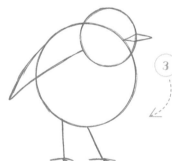

4. Draw the round eye on the edge of the guideline. Colour the pupil black, with a white reflection circle inside.

5. Trace the beak around the triangle guides.

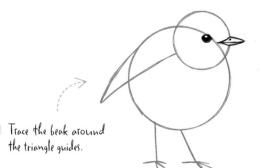

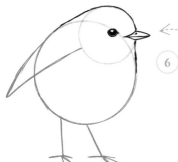

6 Use the circle guides to start tracing the outline of the head and body, using short strokes for the feathery coat.

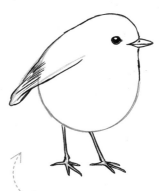

7 Sketch the thin, folded wing on the left with longer strokes. Draw the legs and toes around the guidelines.

8 Complete the outline of the body. Add the tail feathers behind. Sketch a few feathery strokes on the belly. Add some shading on and below the wings.

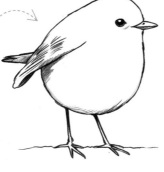

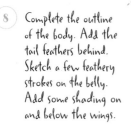

9 Colour the robin light brown, beige and orange, using strokes in the direction of the feathers. Colour the legs pink.

10 Add darker tones around the edges. Finish with some colour on the ground below.

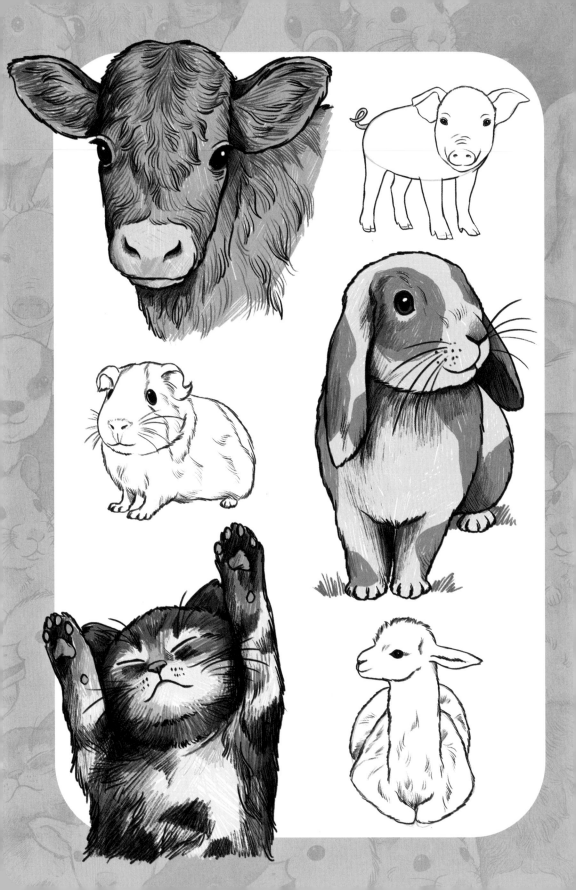

Domestic Animals

Kitten

What could be cuter than a kitten with outstretched paws?
Use long, loose strokes of colour for this tabby's coat of fluff.

1. Draw an oval for the head. Cross it with horizontal and vertical lines through the centre.

2. Sketch guides for the outstretched legs to the sides, with circles on the end for the paws.

3. Above the head circle, add lines for the ears, with two short curves for the neck below.

4. Draw two curves for the closed eyes. Add the nose at the cross of the guidelines, with the curvy mouth below.

5. Trace the fur around the legs with a series of short strokes. Add the five paw pads.

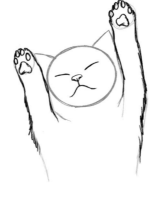

6 Continue tracing the fur around the ears, head and neck. Add little dots on each side of the nose for the base of the whiskers.

7 Add some longer strokes over the face and body. Sketch some whiskers.

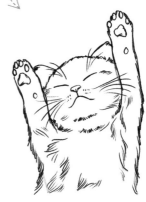

8 Add some shading using one-directional strokes, varying the length of the strokes to look more natural.

9 Colour your kitten in tabby tones of greys and browns, with a pink nose and paw pads.

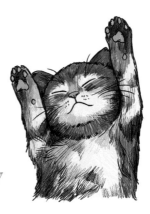

10 Finish with some darker tones for more depth.

Rabbit

Its long, droopy ears and button nose make the lop-eared
rabbit one of the most endearing pets.

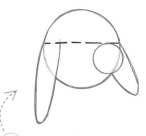

1. Draw a circle for the head.
 Add a dashed line across
 the upper half.

2. Add a smaller circle below
 the guideline to the right for
 the muzzle. Trace two arcs
 for the ears.

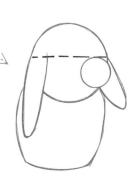

3. Add a U-shape
 below for the body.

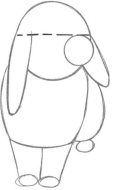

4. Sketch straight lines for the front legs below
 the body, with ovals at the ends for the
 paws. Add a curve to the upper right for
 the back leg, with another oval for the paw.

5. Draw the eye above the guideline.
 Colour the pupil black, with a
 reflection circle inside. Within the
 smaller circle, draw the curvy nose
 and mouth.

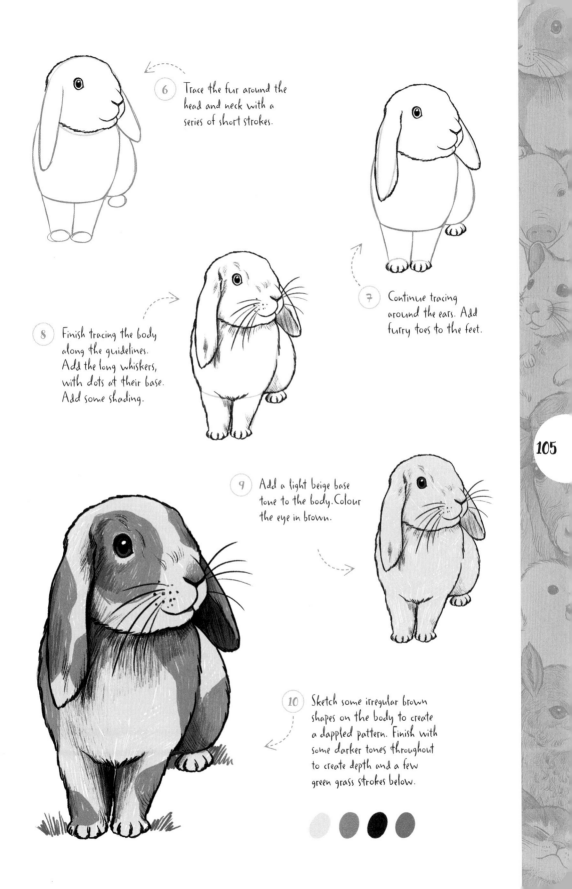

6 Trace the fur around the head and neck with a series of short strokes.

7 Continue tracing around the ears. Add furry toes to the feet.

8 Finish tracing the body along the guidelines. Add the long whiskers, with dots at their base. Add some shading.

9 Add a light beige base tone to the body. Colour the eye in brown.

10 Sketch some irregular brown shapes on the body to create a dappled pattern. Finish with some darker tones throughout to create depth and a few green grass strokes below.

Piglet

Piglets have a large face, with eyes to the sides and a big, pink snout.
Use the guidelines to help position these facial features, with
a few wrinkles above the nose for extra cuteness.

1. Draw a circle for the head, with a small oval below for the snout.

2. Add a dashed line across the lower half of the circle. Join the circles to create the sides of the face. Add a large oval shape around the head for the body.

3. Draw four lines for the legs, with triangles at the end for the trotters.

4. Sketch the curvy ears, with a curly line for the tail.

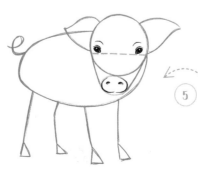

5. Draw the eyes above the guideline, with curved eyebrows above. Colour the pupils black, with white reflection circles inside. Trace the snout around the oval guide. Add the two nostrils.

6. Trace around the top of the head with a series of very short strokes, with longer strokes for the edges of the face and chin.

7. Draw the legs and trotters around the guidelines.

8. Complete the outline of the body and tail.

9. Colour the body in light pink.

10. Add some darker pink to the nose, inside the ears and legs. Finish with some green grass below.

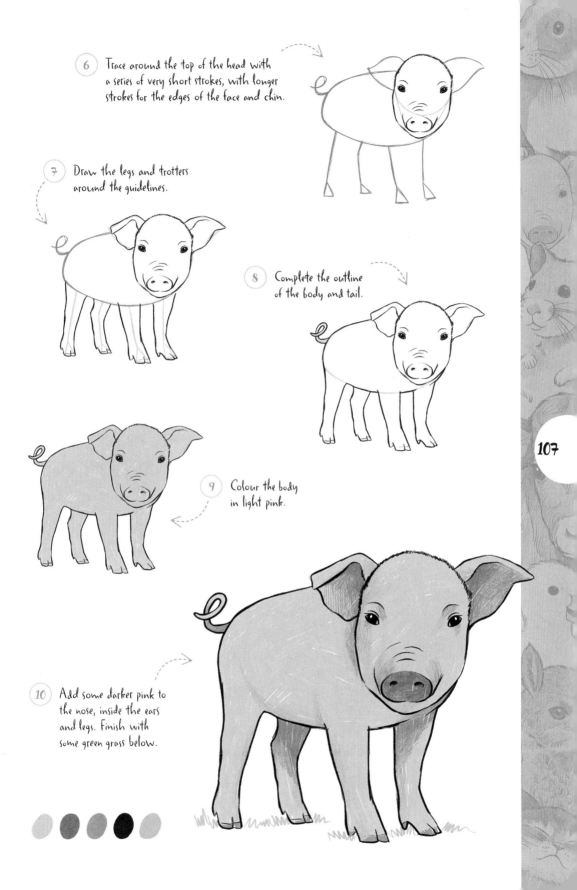

Goat kid

Goats come in many colours. Try this brown-and-white spotted kid,
with grey strokes for an extra-furry effect.

1. Draw an oblong for the head. Add a dashed line across the centre.

2. Add an oval below the dashed line for the muzzle. Sketch two triangular shapes to the sides for the ears.

3. Sketch a circle below for the chest, with a cylinder shape to the right for the body.

4. Draw a series of lines for the legs, with circles for the knee joints and triangles at the ends for the hooves. Add a little curve for the tail.

5. Draw the eyes above the guideline. Add black pupils, with white reflection circles inside. Within the oval guide, sketch the nose and mouth.

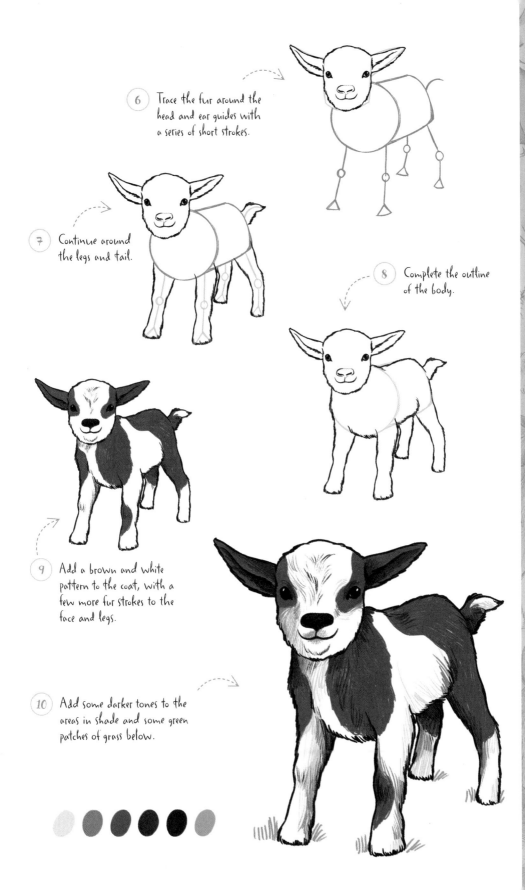

6 Trace the fur around the head and ear guides with a series of short strokes.

7 Continue around the legs and tail.

8 Complete the outline of the body.

9 Add a brown and white pattern to the coat, with a few more fur strokes to the face and legs.

10 Add some darker tones to the areas in shade and some green patches of grass below.

Llama

Like their camel relatives, llamas curl their legs underneath
them when they lie down, a position called a kush.

1 Draw a circle for the head.
 Add a dashed line across
 the centre.

2 Add a U-shape to the left for
 the muzzle and a blade shape
 to the right for the ear.

3 Add a cylinder below
 for the long neck.

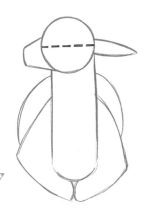

4 Sketch lines for the folded front
 legs each side of the neck. Add
 two curves for the body above.

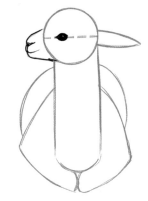

5 Draw the eye on the guideline. Add a
 black pupil and a tiny, white reflection
 circle inside. Trace the nose, mouth and
 chin inside the muzzle guide.

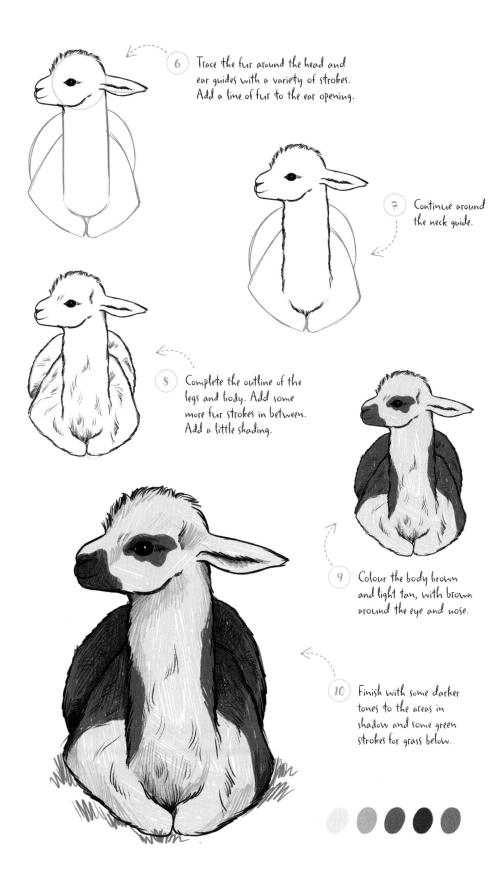

6 Trace the fur around the head and ear guides with a variety of strokes. Add a line of fur to the ear opening.

7 Continue around the neck guide.

8 Complete the outline of the legs and body. Add some more fur strokes in between. Add a little shading.

9 Colour the body brown and light tan, with brown around the eye and nose.

10 Finish with some darker tones to the areas in shadow and some green strokes for grass below.

Lamb

The classic sign of spring and the ultimate in cute, this lamb
is easy to create using a few simple shapes.

1. Draw a circle for the head. Add
a dashed line across the centre.
Add a smaller, overlapping circle
below left for the muzzle.

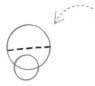

2. Sketch two arcs for the ears.
Connect the two circles with curved
lines for the chin. Add a third circle
below for the chest, about twice
the size of the head circle.

3. Add a U-shape to
the right for the
back and hips.

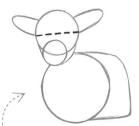

4. Draw lines for the four
legs, with circles for the
knee joints and triangles
for the hooves.

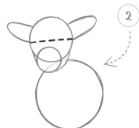

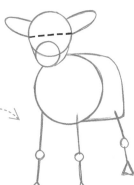

5. Draw the black eyes on the guideline,
with tiny, white reflection circles
inside. Add the nostrils and wavy
mouth inside the muzzle guide.

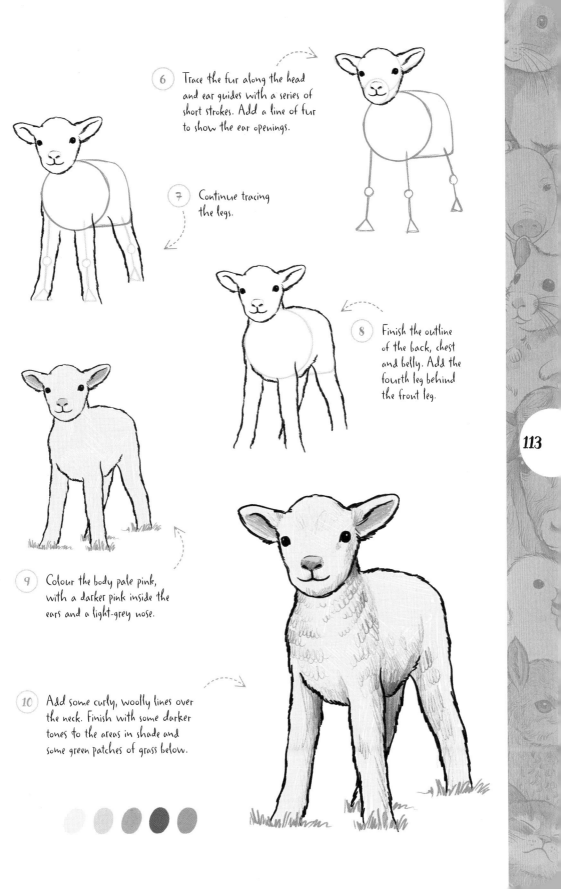

6 Trace the fur along the head and ear guides with a series of short strokes. Add a line of fur to show the ear openings.

7 Continue tracing the legs.

8 Finish the outline of the back, chest and belly. Add the fourth leg behind the front leg.

9 Colour the body pale pink, with a darker pink inside the ears and a light-grey nose.

10 Add some curly, woolly lines over the neck. Finish with some darker tones to the areas in shade and some green patches of grass below.

Alpaca

Alpaca fleece is highly prized for its softness and durability.
Experiment with your strokes to create the alpaca's thick, curly fur.

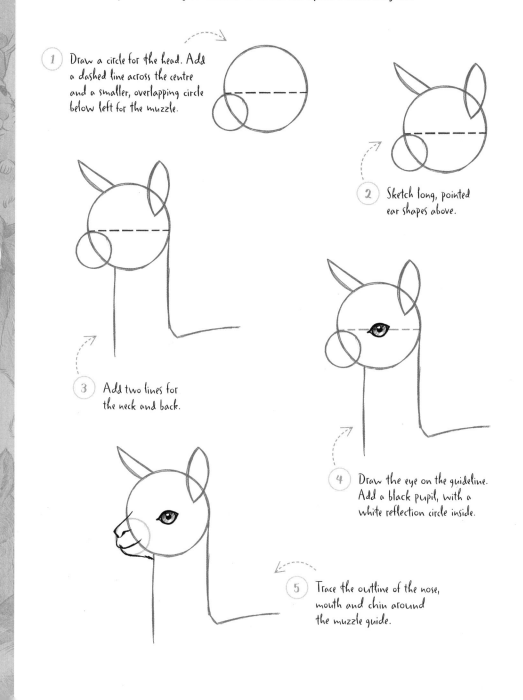

1. Draw a circle for the head. Add a dashed line across the centre and a smaller, overlapping circle below left for the muzzle.

2. Sketch long, pointed ear shapes above.

3. Add two lines for the neck and back.

4. Draw the eye on the guideline. Add a black pupil, with a white reflection circle inside.

5. Trace the outline of the nose, mouth and chin around the muzzle guide.

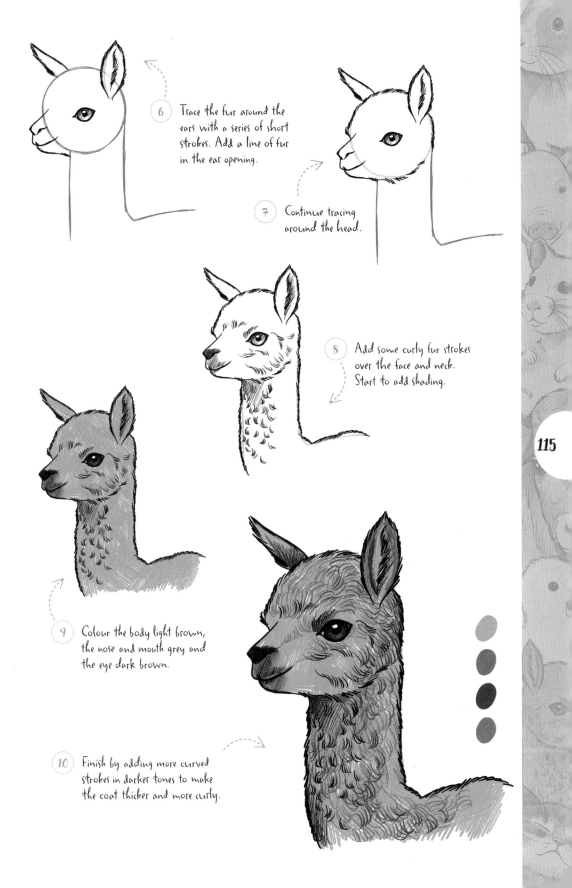

6 Trace the fur around the
 ears with a series of short
 strokes. Add a line of fur
 in the ear opening.

7 Continue tracing
 around the head.

8 Add some curly fur strokes
 over the face and neck.
 Start to add shading.

9 Colour the body light brown,
 the nose and mouth grey and
 the eye dark brown.

10 Finish by adding more curved
 strokes in darker tones to make
 the coat thicker and more curly.

Calf

Calves' big, pink noses and curious brown eyes
make these bovines unbelievably cute.

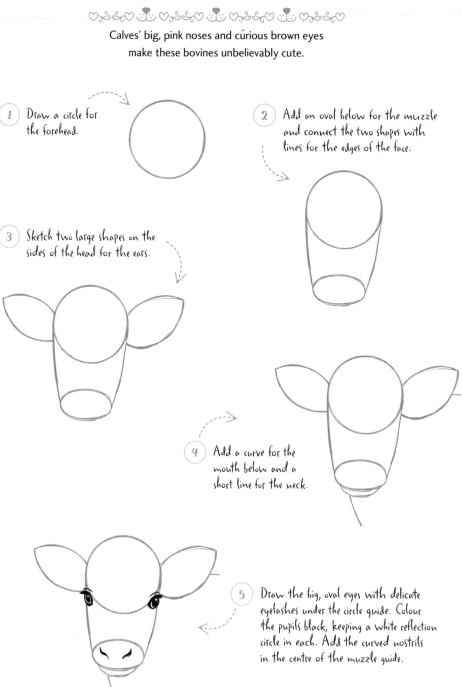

1. Draw a circle for the forehead.

2. Add an oval below for the muzzle and connect the two shapes with lines for the edges of the face.

3. Sketch two large shapes on the sides of the head for the ears.

4. Add a curve for the mouth below and a short line for the neck.

5. Draw the big, oval eyes with delicate eyelashes under the circle guide. Colour the pupils black, keeping a white reflection circle in each. Add the curved nostrils in the centre of the muzzle guide.

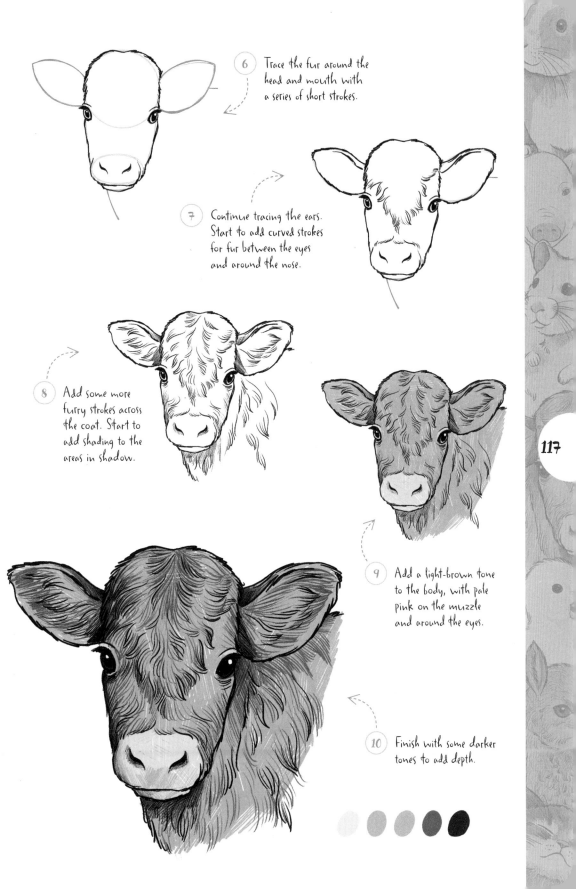

6 Trace the fur around the head and mouth with a series of short strokes.

7 Continue tracing the ears. Start to add curved strokes for fur between the eyes and around the nose.

8 Add some more furry strokes across the coat. Start to add shading to the areas in shadow.

9 Add a light-brown tone to the body, with pale pink on the muzzle and around the eyes.

10 Finish with some darker tones to add depth.

Guinea pig

The guinea pig's round head and plump body contrasts with its tiny feet.
Guinea pigs have four toes on their front feet but only three on their back.

1. Draw a circle for the head. Add a dashed line across the upper half. Sketch a smaller circle to the lower left for the muzzle.

2. Add an oblong shape for the body, with two ovals at the top for the ears.

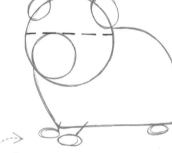

3. Sketch two short lines for the front legs, with ovals at the end for the feet. Add an oval for the back foot to the right.

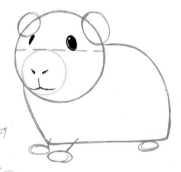

4. Draw the eyes above the guideline. Notice the relative size of each due to perspective. Add a large, black pupil with a white reflection circle. Add the nostrils and mouth inside the smaller circle.

5. Add the curly ears within the guidelines with short strokes for fur.

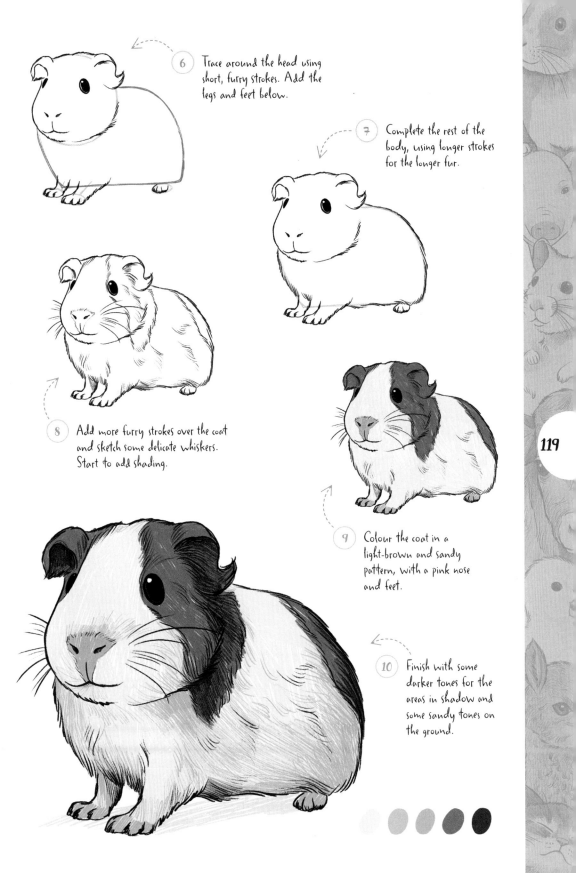

6 Trace around the head using short, furry strokes. Add the legs and feet below.

7 Complete the rest of the body, using longer strokes for the longer fur.

8 Add more furry strokes over the coat and sketch some delicate whiskers. Start to add shading.

9 Colour the coat in a light-brown and sandy pattern, with a pink nose and feet.

10 Finish with some darker tones for the areas in shadow and some sandy tones on the ground.

Duckling

A firm children's favourite, the fluffy duckling is a classic in cute.

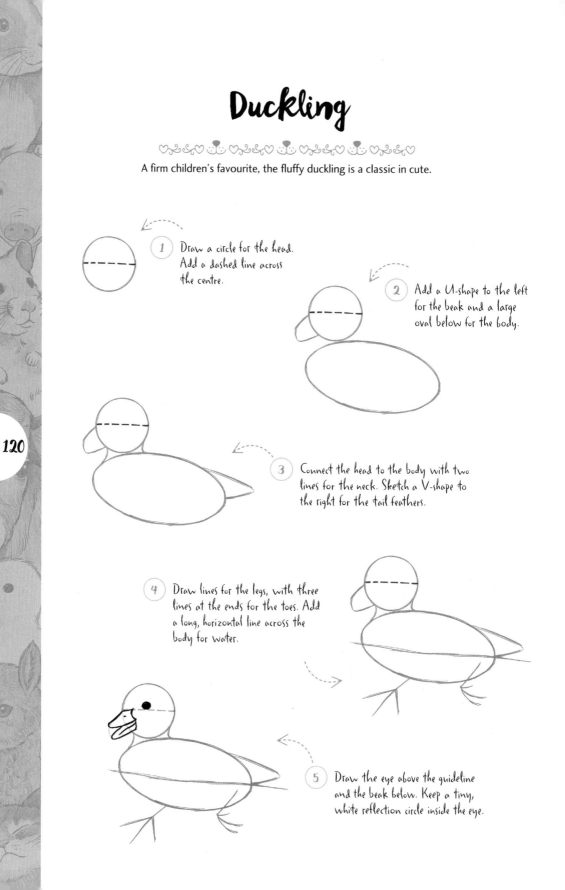

1 Draw a circle for the head. Add a dashed line across the centre.

2 Add a U-shape to the left for the beak and a large oval below for the body.

3 Connect the head to the body with two lines for the neck. Sketch a V-shape to the right for the tail feathers.

4 Draw lines for the legs, with three lines at the ends for the toes. Add a long, horizontal line across the body for water.

5 Draw the eye above the guideline and the beak below. Keep a tiny, white reflection circle inside the eye.

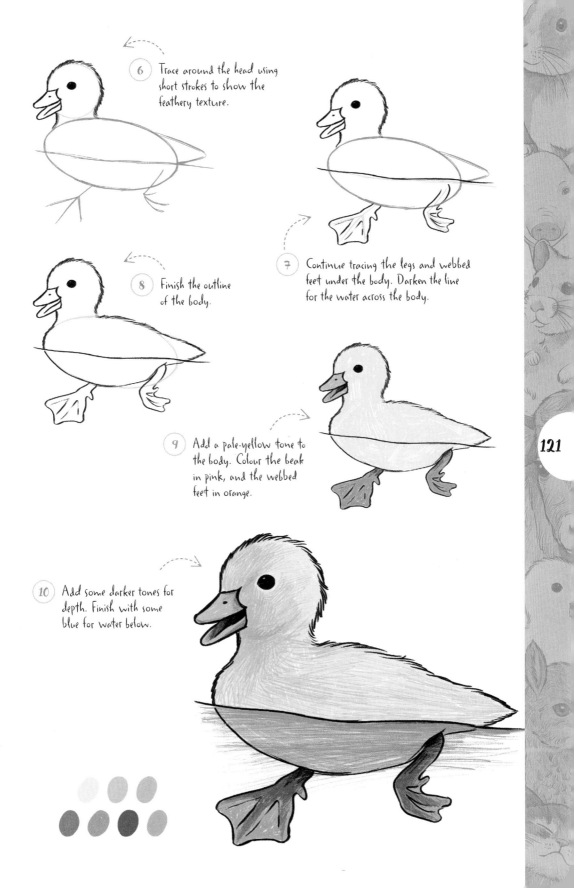

6 Trace around the head using short strokes to show the feathery texture.

7 Continue tracing the legs and webbed feet under the body. Darken the line for the water across the body.

8 Finish the outline of the body.

9 Add a pale-yellow tone to the body. Colour the beak in pink, and the webbed feet in orange.

10 Add some darker tones for depth. Finish with some blue for water below.

Hamster

Hamsters stand up to watch and listen for danger,
their ears alert to the smallest of sounds.

(1) Draw a circle for the head.
Add a dashed line across the
centre. Add a smaller circle
to the right for the nose,
below the dashed line.

(2) Add two arcs on top for
the ears. Notice how one
is smaller due to perspective.

(3) Sketch an oblong below the
head for the body. Add two
circles for the front feet in the
centre and two ovals below
for the back feet.

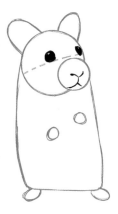

(4) Draw the eyes on the
guideline, with white
reflection dots inside.
Add the nose and mouth
inside the smaller circle.

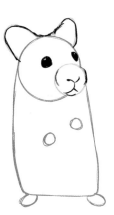

(5) Trace around the ears with quick,
short strokes for fur. Use the smaller
circle guide to add two curves for
the contours of the nose.

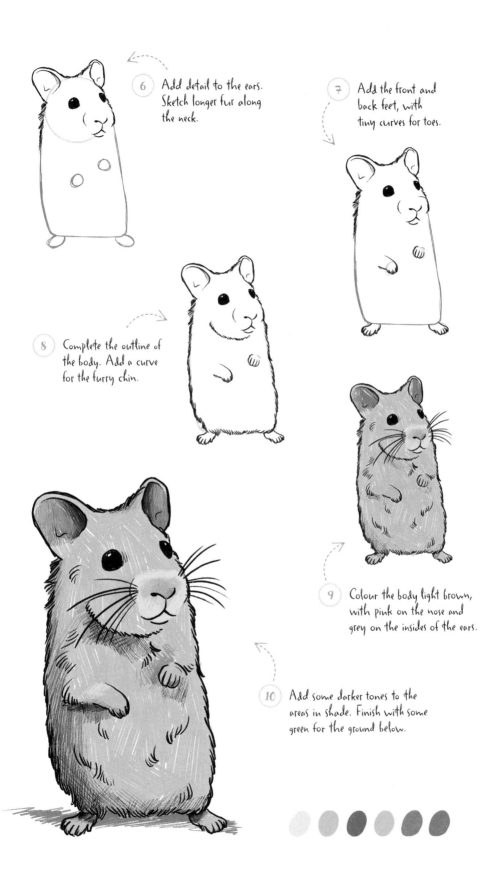

6 Add detail to the ears. Sketch longer fur along the neck.

7 Add the front and back feet, with tiny curves for toes.

8 Complete the outline of the body. Add a curve for the furry chin.

9 Colour the body light brown, with pink on the nose and grey on the insides of the ears.

10 Add some darker tones to the areas in shade. Finish with some green for the ground below.

Puppy

What could be cuter than a chocolate labrador puppy,
looking back at you with inquisitive, innocent eyes?

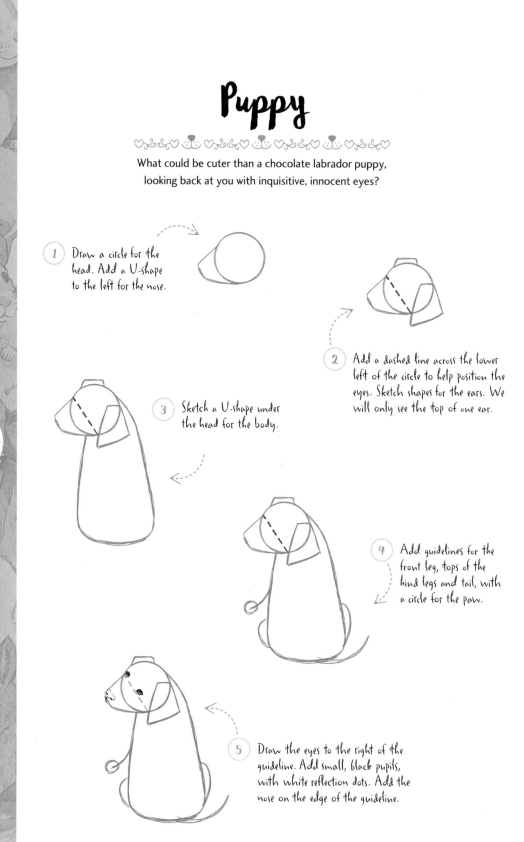

1 Draw a circle for the head. Add a U-shape to the left for the nose.

2 Add a dashed line across the lower left of the circle to help position the eyes. Sketch shapes for the ears. We will only see the top of one ear.

3 Sketch a U-shape under the head for the body.

4 Add guidelines for the front leg, tops of the hind legs and tail, with a circle for the paw.

5 Draw the eyes to the right of the guideline. Add small, black pupils, with white reflection dots. Add the nose on the edge of the guideline.

6 Trace the ears with a series of short strokes for fur.

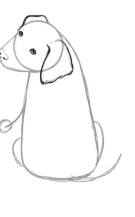

7 Continue tracing around the head and chin with short strokes.

8 Complete the outline of the body and tail, using longer strokes to show the longer fur there.

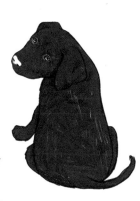

9 Finish tracing the legs and paw. Add some fur strokes around the neck and belly. Colour the puppy brown.

10 Colour the nose and around the eyes pink, with light green to the eyes. Finish with some darker tones to add depth and some colour on the ground.

Donkey

This donkey foal is ready to play! Building from the head
and shoulder guides to the legs will make this furry foal simple.

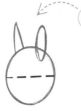

① Draw an oval for the head.
Add a dashed line across the
centre. Sketch two long shapes
for the ears at the top.

② Add a U-shape to the left
for the muzzle. Then add
another, bigger circle below
right for the shoulders.

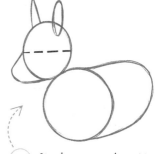

③ Sketch an arc to the right
for the back of the body.

④ Connect the two circles with curves
for the neck. Draw guides for the legs
and tail, with circles for the knees
and triangles for the hooves.

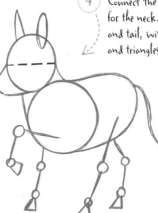

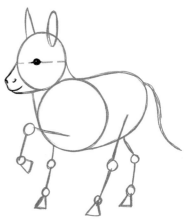

⑤ Draw the eye on the guideline, with a
white reflection dot inside. Trace the
outline of the nose and mouth around
the guideline. Add two nostrils.

6 Trace the fur around the head and ears with a series of short strokes. Add some fur in the ear openings.

7 Continue tracing the legs.

8 Complete the outline of the body. Use long, curved strokes for the tail.

9 Colour the body brown, leaving the nose, belly and inside the ears white. Use a darker brown for the tail and hooves. Add some shading.

10 Finish with some darker tones and some green grass below.

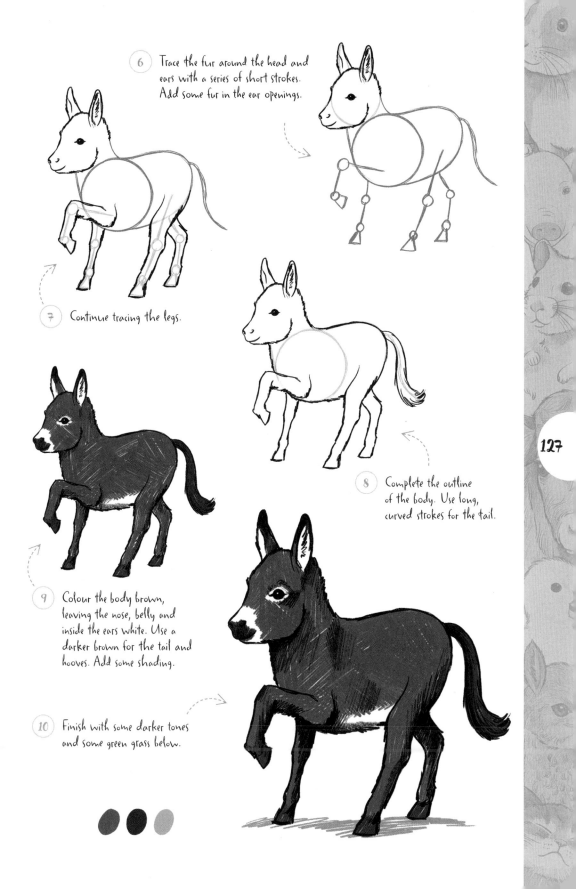

About the Artist

Justine Lecouffe is an illustrator, designer and storyboard artist based in the UK. Her work focuses on digital illustration, graphic design and some dabbling in motion media. Themes of femininity, beauty and nature often dominate her work, making it the perfect fit for clients in the fashion, jewellery and cosmetic sectors. She specializes in design and illustration, but has a long and ambitious wish list of styles and genres to master. When she's not drawing, you can find her cooking comfort food, cycling, snapping film photos, or simply scrolling dog and cat memes.

If you'd like to find out more information or see further examples of her work, find Justine on Instagram @justine_lcf.

Acknowledgements

Many thanks to all the readers of the previous titles in the *10-Step Drawing* series: *People*, *Everyday Things*, *Cats* and *Dogs*, who gave me such positive feedback. This was wonderful encouragement and pushed me to draw for this fifth publication. I love seeing your drawings, so feel free to continue sending them through my Instagram.

I'm again immensely grateful to the team at The Bright Press for another fantastic opportunity and their brilliant support throughout the project.